ARTE LATINO

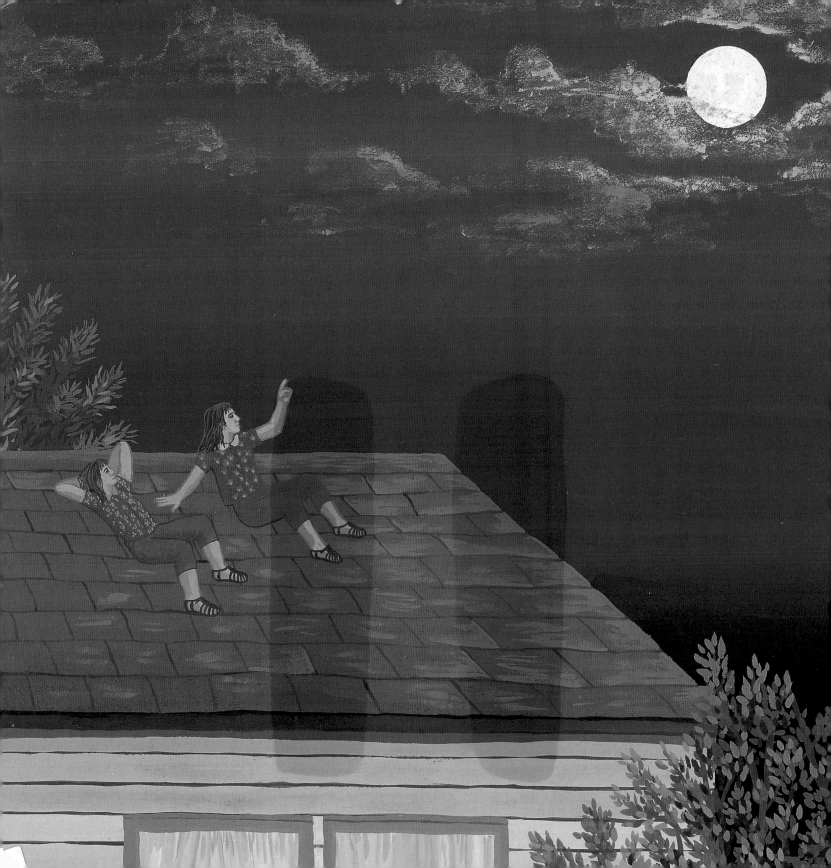

ARTE LATINO

Treasures from the
Smithsonian American Art Museum

Jonathan Yorba

Watson-Guptill Publications/New York

Smithsonian American Art Museum

Arte Latino: Treasures from the Smithsonian American Art Museum

By Jonathan Yorba

Chief, Publications: Theresa Slowik
Designers: Steve Bell, Karen Siatras
Editor: Timothy Wardell
Editorial Assistant: Sara Mauger

Library of Congress Cataloging-in-Publication Data

Yorba, Jonathan.
 Arte latino : treasures from the Smithsonian American Art Museum / Jonathan Yorba.
 p. cm.
 Includes index.
 ISBN 0-8230-0321-3
 1. Hispanic American art—Exhibitions. 2. Art, Modern—20th century—United States—Exhibitions. 3. Art—Washington (D.C.)—Exhibitions. 4. Smithsonian American Art Museum—Exhibitions. I. Smithsonian American Art Museum II. Title.
 N6538.H58 Y67 2001
 704.03'68073'07473—dc21
 00-012913

Printed and bound in Italy

First printing, 2001
1 2 3 4 5 6 7 8 9 / 08 07 06 05 04 03 02 01

© 2001 Smithsonian Institution
First published in 2001 by Watson-Guptill Publications, a division of BPI Communications, 770 Broadway, New York, NY 10003, in association with the Smithsonian American Art Museum.

Cover: Patssi Valdez, *The Magic Room* (detail), 1994, acrylic. Smithsonian American Art Museum, Museum purchase through the Smithsonian Institution Collections Acquisition Program (see page 106).

Frontispiece: Carmen Lomas Garza, *Camas para Sueños* (Beds for Dreams)(detail), 1985, gouache. Smithsonian American Art Museum, Museum purchase through the Smithsonian Institution Collections Acquisition Program (see page 46).

Arte Latino is one of eight exhibitions in *Treasures to Go,* from the Smithsonian American Art Museum, touring the nation through 2002. The Principal Financial Group® is a proud partner in presenting these treasures to the American people.

The Smithsonian Center for Latino Initiatives provided additional support for this exhibition and book.

Foreword

Museums satisfy a yearning felt by many people to enjoy the pleasure provided by great art. For Americans, the paintings and sculptures of our nation's own artists hold additional appeal, for they tell us about our country and ourselves. Art can be a window to nature, history, philosophy, and imagination.

The collections of the Smithsonian American Art Museum, more than one hundred seventy years in the making, grew along with the nation itself. The story of our country is encoded in the marvelous paintings, sculptures, and other artworks we hold in trust for the American people.

Each year more than half a million people come to our home in the historic Old Patent Office Building in Washington, D.C., to see great masterpieces. I learned with mixed feelings that this neoclassical landmark was slated for renovations. Cheered at the thought of restoring our magnificent showcase, I felt quite a different emotion on realizing that this would require the museum to close for three years.

Our talented curators quickly saw a silver lining in the chance to share our greatest, rarely loaned treasures with museums nationwide. I wish to thank our dedicated staff who have worked so hard to make this dream possible. It is no small feat to schedule eight simultaneous exhibitions and manage safe travel for more than five hundred precious artworks for more than three years, as in this *Treasures to Go* tour. We are indebted to the dozens of museums around the nation, too many to name in this space, that are hosting the traveling exhibitions.

The Principal Financial Group® is immeasurably enhancing our endeavor through its support of a host of initiatives to increase national awareness of the *Treasures to Go* tour so more Americans than ever can enjoy their heritage.

Written by Jonathan Yorba, *Arte Latino* explores the rich vein of Latino culture that runs through the American hemisphere. The works selected for the exhibition and the book span more than 200 years and include sculpture, painting, and photography. They were created by a diverse array of Puerto Rican, Mexican American, Cuban American, Central American, and South American artists. Some are intensely political, while others examine the nature of personal identity or declare the power of place to shape us. Each work makes us pause for simple delight or profound thought.

America, a land of immigrants, and American art owe a profound debt to the Latino population. Hispanics were among the earliest settlers of this continent, and their influence has been proportionally strong. This can be seen in our museum, where the earliest works in the collection were made by Puerto Rican artists and some of the most contemporary images reflect diverse Latino cultures.

The Smithsonian American Art Museum is planning for a brilliant future in the new century. Our galleries will be expanded so that more art than ever will be on view, and we are planning new exhibitions, sponsoring research, and creating educational activities to celebrate American art and understand our country's story better.

Elizabeth Broun
Margaret and Terry Stent Director
Smithsonian American Art Museum

CARLOS ALFONZO

1950–1991

Where Tears Can't Stop

1986, acrylic
243.2 x 325.8 cm
Smithsonian
American Art
Museum
Museum purchase
made possible
by the American
Art Forum

In 1980, Carlos Alfonzo was among the many Cuban émigrés who departed by boat from Mariel Harbor to come to the United States. Disillusioned with Fidel Castro's cultural and social policies, the artist was granted asylum and settled in Miami. Alfonzo remarked, "My work has been nourished by two currents—one, the Cuban, of drama and chaos; and two, the American, of rationality and structure. Between these two currents my work grows."

In this large and energetic painting, Alfonzo has included symbols from *Santería*—a religion that blends Roman Catholic and African spiritual traditions—alongside those of the Tarot and Rosicrucian mysticism. This visual hybrid of cultural beliefs and symbols suggests martyrdom and sacrifice. Indeed, Alfonzo's expressive, even painful, image could be read as apocalyptic. The densely packed surface includes large teardrops, severed limbs, clenched teeth, multiple crosses, and sharp daggers piercing eyes and tongues—the last perhaps serving to ward off evil. The artist stitched together pieces of cloth to enlarge the space of this powerful painting. Through his complex and personal iconography, Carlos Alfonzo connects the image to his vivid memories of his homeland as a "place of frustration, violence, and fear" as well as to the violence he found in the United States.

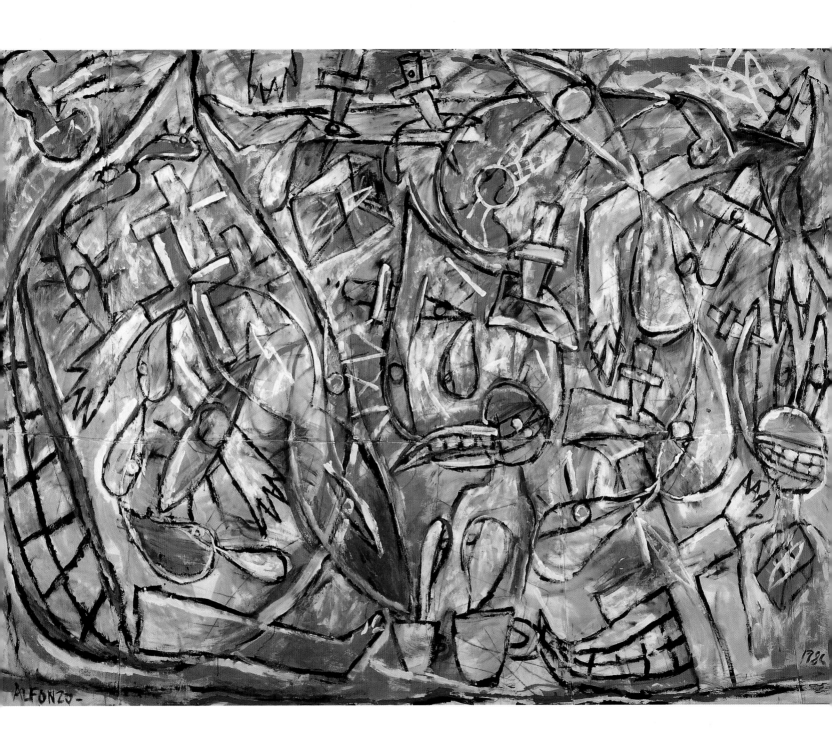

CARLOS ALMARAZ

1941–1989

Homage to Still Life

1986, oil
182.9 x 275 cm
Smithsonian
American Art
Museum

Carlos Almaraz is described as a "painterly painter" whose works are rich in thick, sensuous pigment. In *Homage to Still Life,* Almaraz has combined still-life elements of bottles, wine goblets, and fruit with female models and sculpture atop a pedestal, evoking the traditional studio space of the artist. These are juxtaposed with Mexican masks, cars speeding on a freeway, and even a ballot box. Elsewhere in the frenetic scene a girl playing with a hoop runs toward a larger-than-life multicolored rabbit, while a man appears on a television screen, perhaps a newscaster reporting on the day's top stories. At lower right is the artist's self-portrait, drawn as a simple profile study. Almaraz sips a cup of coffee as he gazes calmly upon his creation and his world.

Born in Mexico City in 1941, Carlos Almaraz soon moved with his family to the United States, settling eventually in East Los Angeles. Almaraz was aware from an early age of a "bifurcation" in his surroundings. He studied at California State College at Los Angeles, the Otis Art Institute, and the University of California at Los Angeles, and spent a few years in New York before returning to California. In the 1970s he became involved with César Chávez's farm workers' movement, Luis Valdez's Teatro Campesino, and Mechicano, a cooperative gallery in East Los Angeles. Almaraz was one of the founding members of the Chicano art collective Los Four, whose other members included Gilbert "Magu" Luján, Roberto de la Rocha, and Frank Romero.

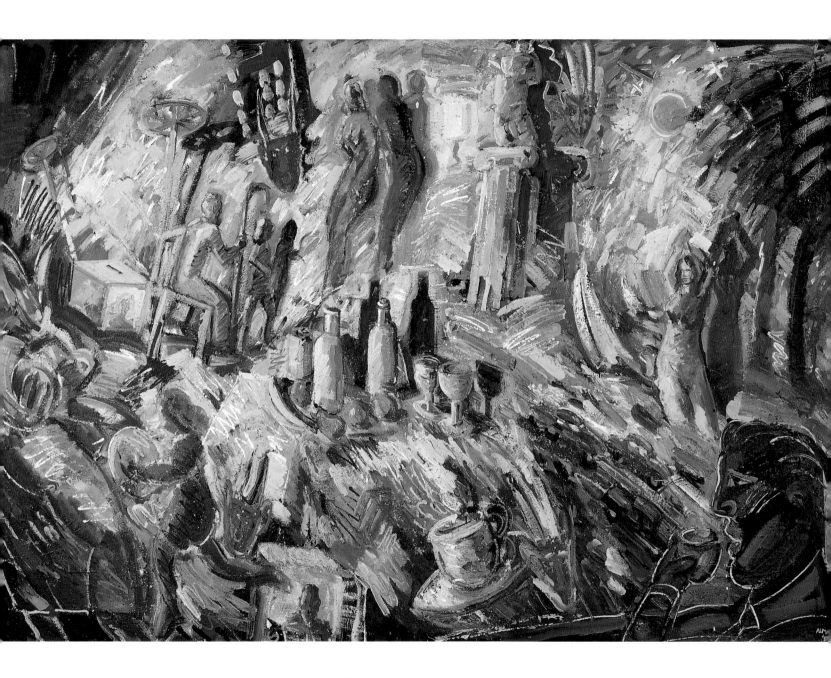

ALFREDO ARREGUÍN

born 1935

Sueño
(Dream: Eve
before Adam)

1992, oil
183.5 x 366.4 cm
Smithsonian
American Art Museum
Museum purchase
through the Luisita L. and
Franz H. Denghausen
Endowment and the
Smithsonian Institution
Collections Acquistion
Program

JUDITH F. BACA

born 1946

Las Tres Marías (The Three Marys)

1976, colored pencil
on paper, wood,
cloth, and mirror
173.4 x 127.6 x 5.7 cm
Smithsonian
American Art Museum
Museum purchase
made possible
by William T. Evans

Judith Baca is a Chicana artist, professor, arts administrator, community leader, and social and cultural activist. She was the founder and artistic director of the Social and Public Arts Resource Center in Venice, California. She also worked with the community on *The Great Wall of Los Angeles,* which is located in the Tujunga Wash drainage canal in the San Fernando Valley. Begun in the late 1970s and still in progress, it is the longest mural in the world, measuring more than a half mile long. A feminist, Baca was profoundly influenced by her matriarchal upbringing in South Central Los Angeles. She has commented, "On a spiritual and emotional level, mine has been a community of women, some within my own culture but many not."

Two strong women flank a mirror that serves to place the viewer at the center of the visual field. At left is a modern young *chola* (contemporary member of street gang), dressed casually and gazing unflinchingly at the viewer, her hands in her pockets. At right is a portrait of Baca dressed as a *pachuca* (member of street gang from the 1940s), taking a drag from her cigarette. Through her updating of the centuries-old theme of the three Marys of the crucifixion, Baca explores personal and cultural identity and challenges the viewers to position themselves—literally and figuratively—on such issues as gender, ethnicity, and class.

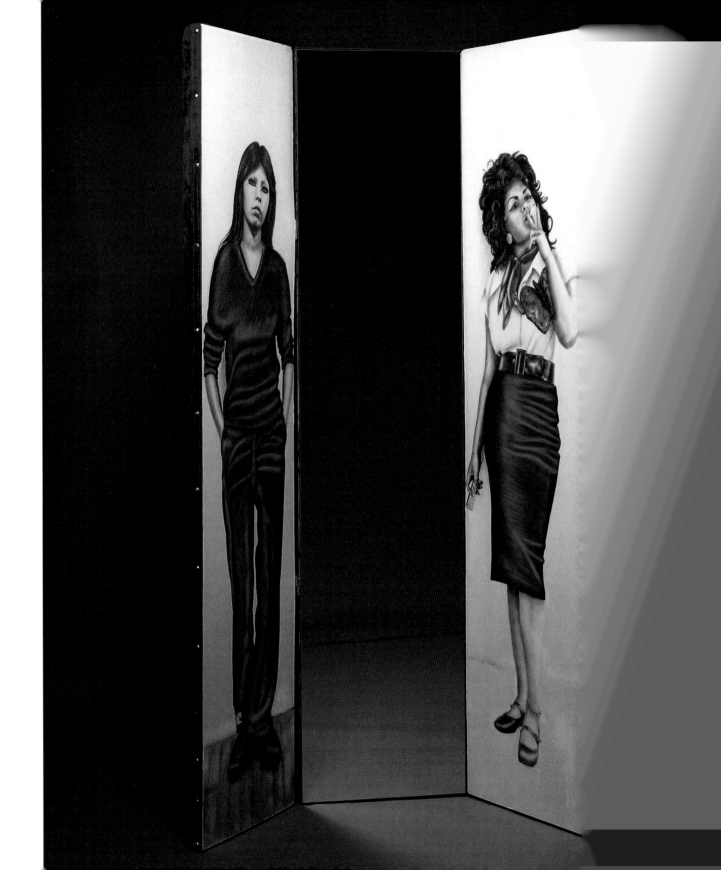

PATROCIÑO BARELA

1908–1964

Saint George

about 1935–43
juniper
43.2 x 26.7 x
14.6 cm
Smithsonian
American Art
Museum
Transfer from the
General Services
Administration

Saint George stands triumphant, holding a cross-shaped spear to pierce the crude beast, symbolic of the devil, causing its eyes to bulge in fear: Will the locals convert to Christianity, thereby vanquishing his powers? The saint is dressed in simple clothing; the mail that covers his forehead and nose is the only protection that he wears. The grain of the juniper and rough chisel marks add visual interest to this viscerally powerful work. Although only seventeen inches high, the work appears monumental.

The artist was born in Arizona but lived and labored in New Mexico, where he is credited with transforming traditional carving into a modern, personal idiom. Barela has been critically praised for his "crude, honest, personal expression." This sculpture is characteristic of Patrociño Barela's straightforward, expressive carvings on such themes as spirituality, morality, strength, and struggle.

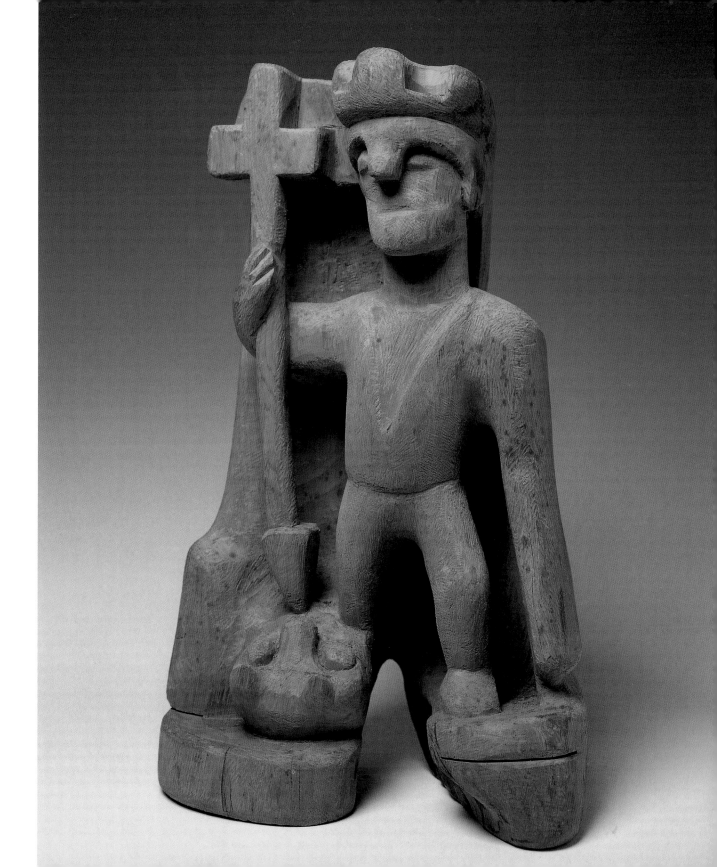

CHARLES "CHAZ" BOJÓRQUEZ

born 1949

Somos La Luz (We Are the Light)

1992, oil,
aluminum paint, and
aluminum leaf
143.2 x 224.2 x 8.9 cm
Smithsonian
American Art Museum
Museum purchase
through the Luisita L. and
Franz H. Denghausen
Endowment and the
Smithsonian Institution
Collections Acquistion
Program

Considered by many as an antisocial act, graffiti is for some Latinos a contemporary art form with a rich intergenerational tradition. In *Somos La Luz,* using gradations of silver-gray to black, the artist overlays different type and writing styles, creating rich texture and energy. The Roman numerals XLIII are painted in the far left corner, an allusion to Avenue 43 in Los Angeles—the artist's home territory. The darker letters form the names of young writers, an emerging generation working to legitimize graffiti language from the "dark underground" to the "steel strength and light of acceptance." The words *Somos La Luz,* located on the left of this wall-sized painting, show this transformation, the letters aglow with their bright outlines.

Like many artists of his generation, Bojórquez was inspired by the Chicano movement for civil rights to create art that functions on multiple social and aesthetic levels. Although he lives in Los Angeles— a city from which he draws great inspiration—Bojórquez has traveled to several countries and regions, including the South Pacific, Asia, and Europe, in search of other calligraphic languages.

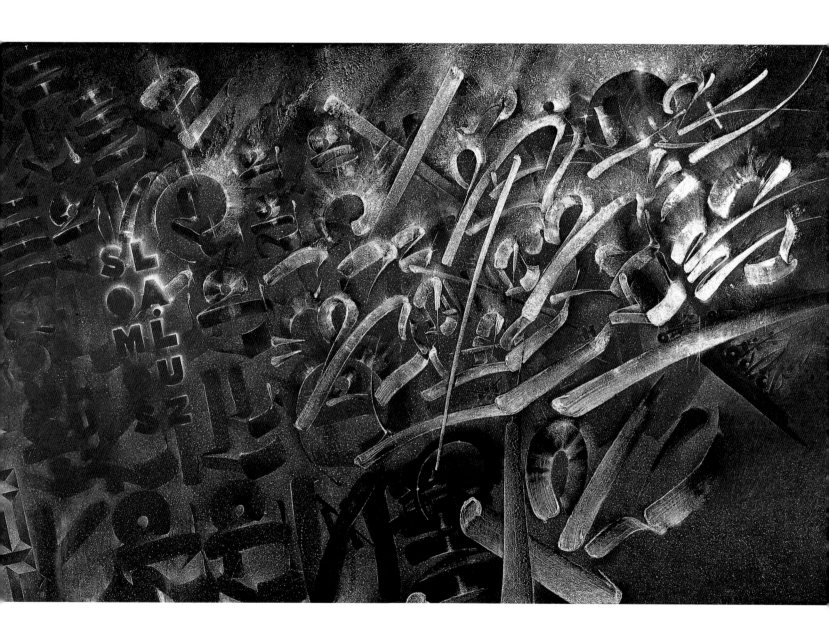

MARÍA BRITO

born 1947

El Patio de Mi Casa (The Patio of My House)

1990, acrylic on wood
and mixed media
242.6 x 173.4 x 165.1 cm
Smithsonian
American Art Museum
Museum purchase
through the Smithsonian
Institution Collections
Acquistion Program

This installation contains memories of the past and present for María Brito, a Cuban-born artist who lives in Miami. While constructing it she found herself humming a nursery rhyme from her childhood in Havana that gave the work its title: *El Patio de Mi Casa.*

A large, dark crack on the floor indicates a fissure of time and place—of memory. This is further amplified by ominous shadows of tree branches on the crib. The reality of adulthood is represented by the kitchen, in which Brito has carefully arranged utensils. The kitchen cabinet is partially open, allowing a glimpse of elements from the artist's past. A fragile glass jar containing a small house sits on the sink counter in front of an old photograph. The artist was almost three years old when the snapshot was taken, likely at a birthday party. Of the three little girls at the bottom of the photograph, Brito is in the middle. She wears a striped party hat and a puzzled look. A small fragile twig sits in water in the sink, with the hope that it will sprout. As a symbol of fertility, it might signify the regeneration of physical and cultural ties.

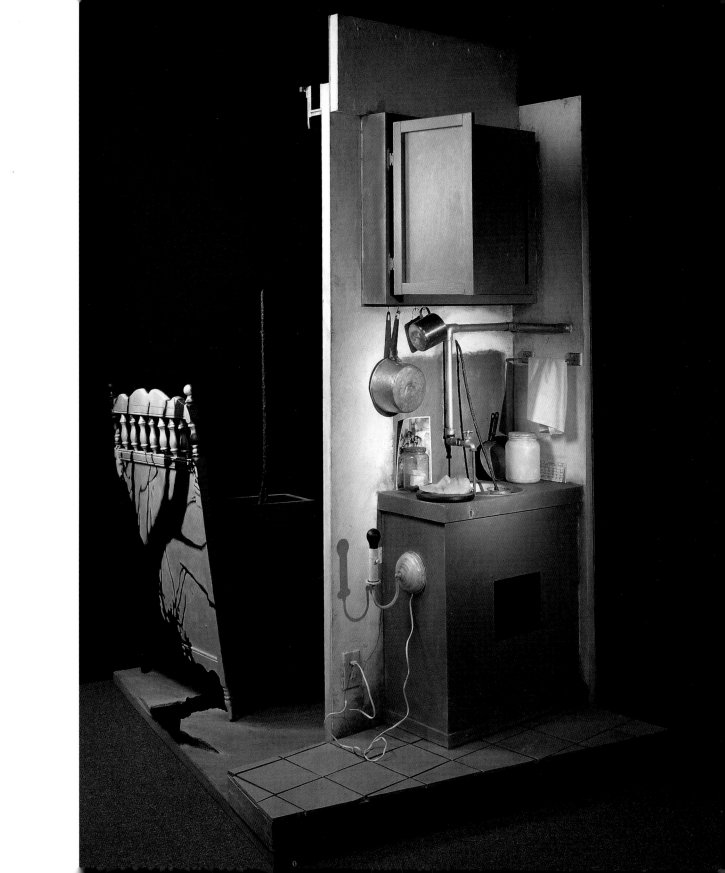

CABAN GROUP

active Puerto Rico,
mid-nineteenth–
mid-twentieth centuries

Los Reyes Magos (The Three Magi)

about 1875–1900
painted wood with
metal and string
20.7 x 30.3 x 15.3 cm
Smithsonian
American Art Museum
Teodoro Vidal Collection

Guided by the Star of Bethlehem, the Three Magi (Balthasar, Gaspar, and Melchior) rest astride their sturdy horses. The Feast of the Epiphany on January 6 commemorates their arrival in Bethlehem and the revelation of Jesus as the Christ to the Magi, who symbolically represent the first converts from paganism to Christianity. In Puerto Rico, as elsewhere, the day is celebrated with gifts to the children, constituting a second Christmas.

Contrary to other cultures where Balthasar is the dark king, in Puerto Rico it is Melchior. In this figural grouping he is represented in the middle of the triad, flanked by the two white kings. According to local tradition, Melchior is black because he has been burnt by the rays of a star. The gifts they bear have allegorical significance—the gold, incense, and myrrh are symbols of Christ as king, god, and mortal. In anticipation of their arrival, *puertorriqueño* children leave boxes of hay and bowls of water under their beds for the kings' horses.

These delightful figures were carved in the style of the Caban family. For several generations the Cabans worked in the town of Camuy, although works produced in their distinct style are found throughout the island.

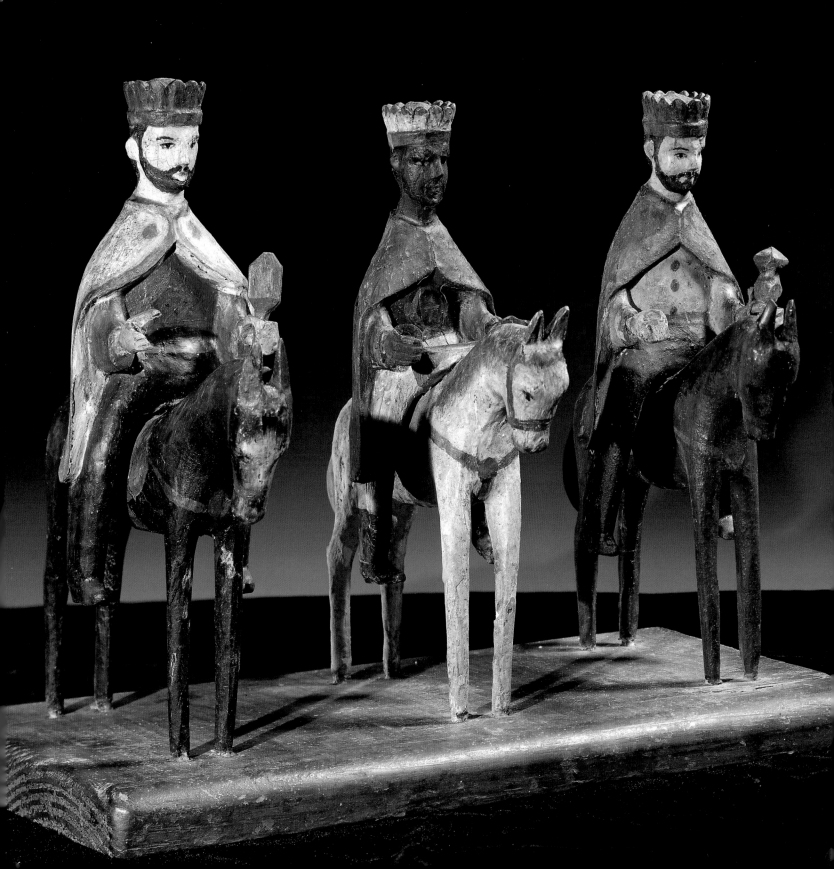

JOSÉ CAMPECHE

1751–1809

San Juan Nepomuceno (Saint John Nepomuk)

about 1798, oil
106.1 x 74.9 cm
Smithsonian
American Art Museum
Teodoro Vidal Collection

In the fourteenth century, John Nepomuk was the confessor to Queen Johanna of Bohemia. Her husband, King Wenceslaus IV, ordered the confessor killed when he refused to break the seal of confession and divulge the queen's secrets. Canonized as a saint in 1729, Nepomuk is invoked as the patron saint of confession, silence, and against slander, often depicted with a finger on his lips or a padlock on his mouth. In this devotional image, six-pointed stars surround the saint's head, each bearing a capital letter forming the word TACUI, Latin for "I did not speak."

José Campeche was the most significant Puerto Rican painter of portraits and religious imagery. Of Afro-Caribbean ancestry, he was the son of a slave who purchased his freedom. Although primarily self-taught, Campeche was influenced by the exiled Spanish court painter Luis Paret y Alcázar, who lived in Puerto Rico from 1775 through 1778. This painting was commissioned for the cemetery chapel in Caracas at a time when Venezuela, like Puerto Rico, was under the Spanish crown.

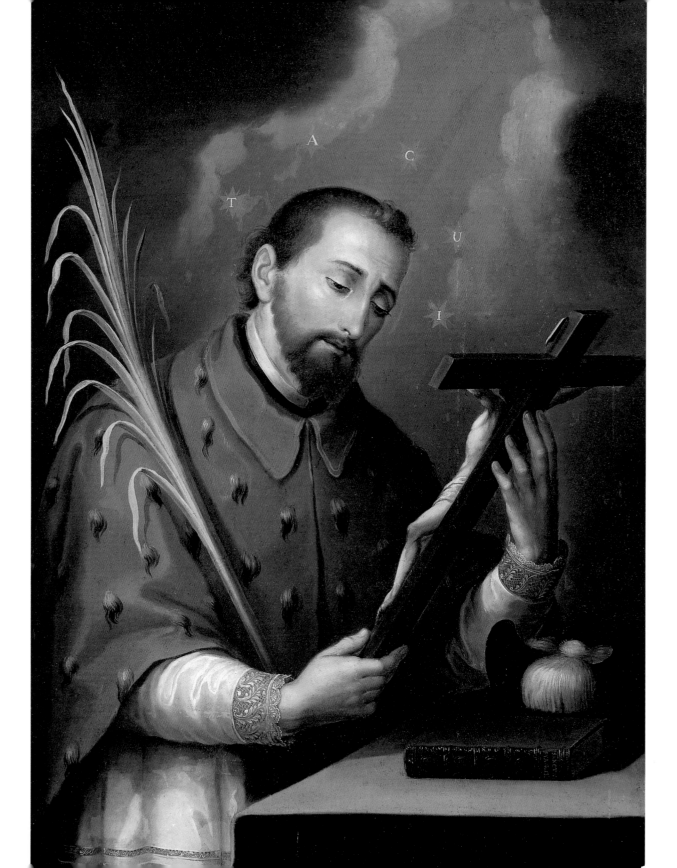

CHARLES M. CARRILLO

born 1956

Devoción de Nuevo México
(Devotion of New Mexico)

1998, gesso and natural
pigments on pine
245.1 x 152.4 x 55.3 cm
Smithsonian
American Art Museum
Museum purchase
made possible by
William T. Evans and the
Smithsonian Institution
Collections Acquisition
Program

In this impressive and carefully balanced New Mexican colonial style *reredos* (altar screen), Carrillo brings to bear the full range of his skills as a carver. On the *remate* (crown), the Holy Spirit, represented by a white dove, descends toward images of the cross-bearing Christ and God the Father, uniting them with its radiance. Together the three represent the Holy Trinity. Flanking this central panel are images of *San Rafael Arcángel* and *San Miguel Arcángel.* Below them are representations of *Santo Domingo* and *San Francisco.* The curtained central niche is reserved for a figure of the church's patron saint.

In keeping with nineteenth-century tradition, Carrillo made this pine altar using a mortise-and-tenon technique, without the use of nails or screws. The rich colors are hand-made from natural pigments derived from minerals, plants, and natural clays. Although much smaller in scale, this *reredos* includes the same figures of saints as the main altar of the nineteenth-century Catholic church in the village of Las Trampas.

A prominent anthropologist, cultural historian, and teacher, Charles Carrillo has been called a "cultural warrior" for his zealous enthusiasm. He refers to the "belief system" as essential to the carver of religious figures. "If I truly didn't believe in it, I couldn't do it. If you don't believe, you are just a painter of images."

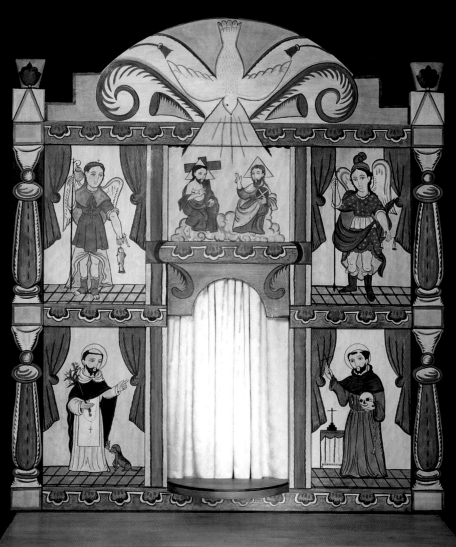

MEL CASAS

1929–1987

Humanscape 141: Barrio Dog

1987, acrylic
190.5 x 254 cm
Smithsonian
American Art Museum
Museum purchase
through the Luisita L. and
Franz H. Denghausen
Endowment

In the mid-1960s, the surreality of projected images on a large drive-in screen prompted Casas to begin a series he calls *Humanscape*. These large paintings use a movie-theater format to critique and counter powerful media images from cinema, television, and advertisements. According to the artist, "Each painting has a subtitle which is incorporated into the visual structure of the painting." The result, he continues, "is a series of puns, both literal and visual" that present a critical point of view.

In this dazzling painting a large black dog from the barrio glowers at the viewer. With its full bristling coat, wide round eyes, and sharp white teeth, it spews spittle in all directions and emits a *bowguau*, bilingual bark. The source of the dog's frustration is the multiple bones that float in a separate blue field, out of reach of the animal's mouth—symbolic of the inaccessible plenty in the surrounding culture.

Melesio Casas, born in El Paso, is a trenchant cultural critic who conveys the message of an oppressive world in which a dangled carrot—or, in this case, a bone—highlights the unequal distribution of wealth between south Texas barrios and affluent communities.

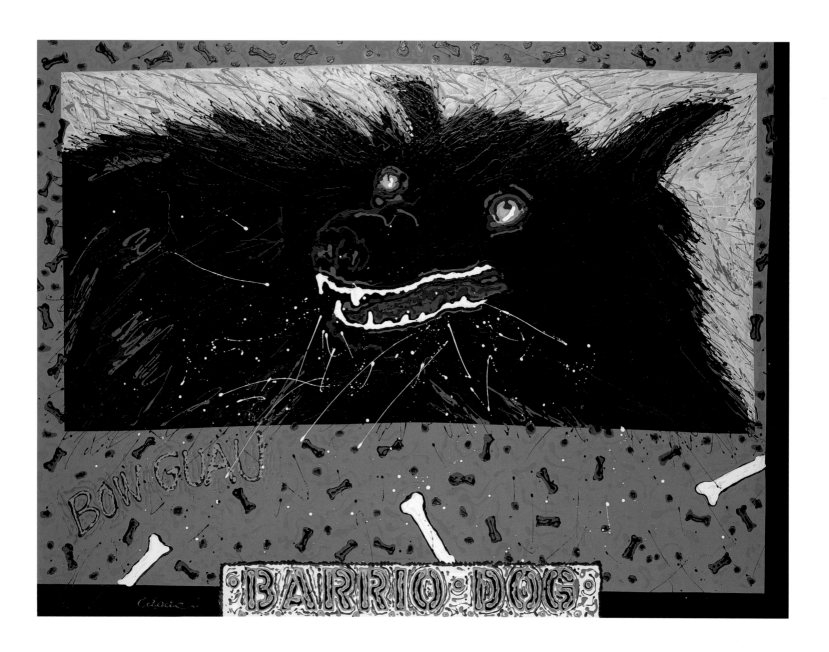

MARÍA CASTAGLIOLA

born 1946

A Matter of Trust

1994, paper on fiberglass
with cotton thread
183 x 183 x .3 cm
Smithsonian
American Art Museum
Gift of the artist

Castagliola arranged ordinary paper envelopes in traditional quilt patterns of squares, rectangles, and triangles to create a contemporary work about intimacy and trust. Family members, friends, and acquaintances provided the Cuban-born artist with their deeply personal secrets, which she sewed shut inside these envelopes.

"There are very few relationships," the artist states, "in which you can share everything and trust that there is going to be support and understanding." Castagliola collected these secrets with the understanding that they were never to be opened. To ensure this, she sealed the quilt between sheets of fiberglass window screen. This added a formal element to the artwork, the padded surface shimmering with yet another pattern.

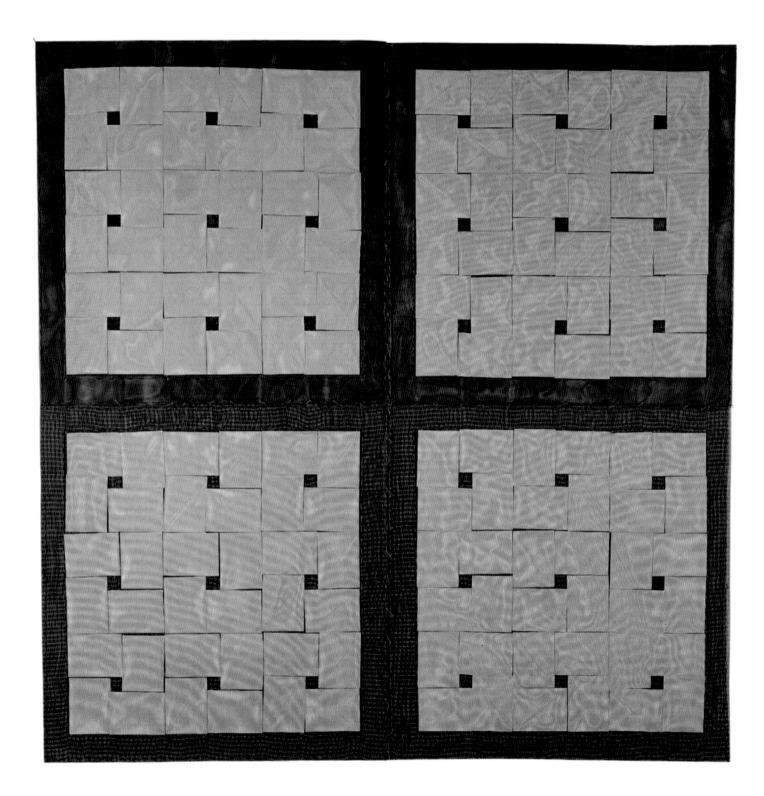

ALFREDO CEIBAL

born Guatemala 1952

Señor Presidente's Wake

1988–93, acrylic
Smithsonian
American Art Museum
Museum purchase
through the
Catherine Walden
Myer Endowment, the
Luisita L. and Franz H.
Denghausen Endowment,
and the Acquisitions
Gift Fund

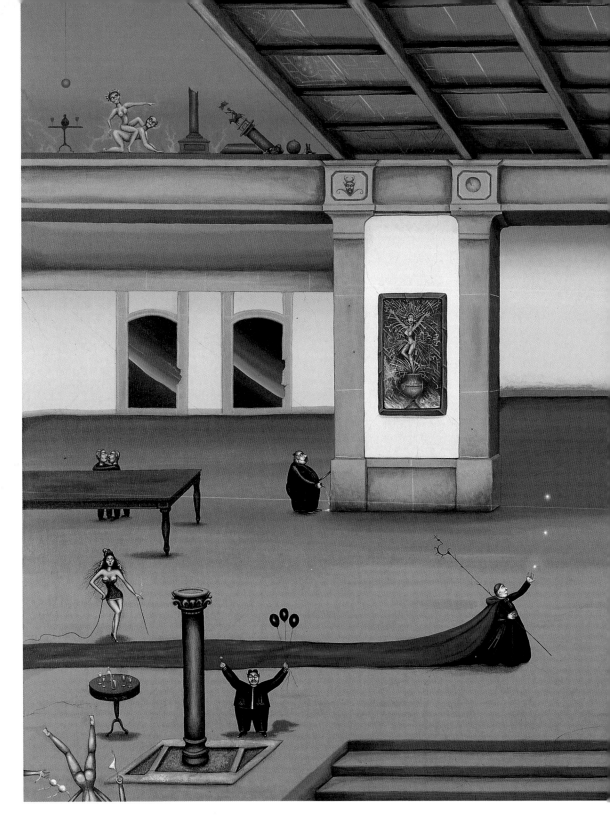

FELIPE de la ESPADA

1754–1818

San Benito Abad (Saint Benedict the Abbot)

about 1770–1818

painted cedar with glass

87 x 41.3 x 34.9 cm

Smithsonian

American Art Museum

Teodoro Vidal Collection

This astonishingly life-like figure of Saint Benedict the Abbot, the sixth-century founder of the Benedictine order, extends his right hand, which once likely held a book or other object, while his left hand probably grasped a staff. De la Espada has depicted the abbot in the typical black habit of the order, with its long, wide sleeves and hood. At the time of this carving, Benedictine monks were resident on the Caribbean island. Although they could have served as models, European baroque sculptures, with their naturalistic rendering, would also have been available. Wrinkles on the abbot's forehead speak to his concern for others, while the sculpture's glass eyes—inserted from behind—sparkle with life. Other distinguishing characteristics are the long, flowing beard and his monastical hair cut—a thin, open circle with a punctuating tuft.

In the old town of San Germán, located in the southwestern region of Puerto Rico, the production of *santos,* colorful wooden images of saints that are prayed to in times of public and private devotion, was an important business. This is where Felipe de la Espada and his family lived and worked. Of African ancestry, he was one of the most respected *santeros* in colonial times. In addition to his great skill as a carver, de la Espada was one of very few in his community who could read—a notable accomplishment for a man of humble beginnings.

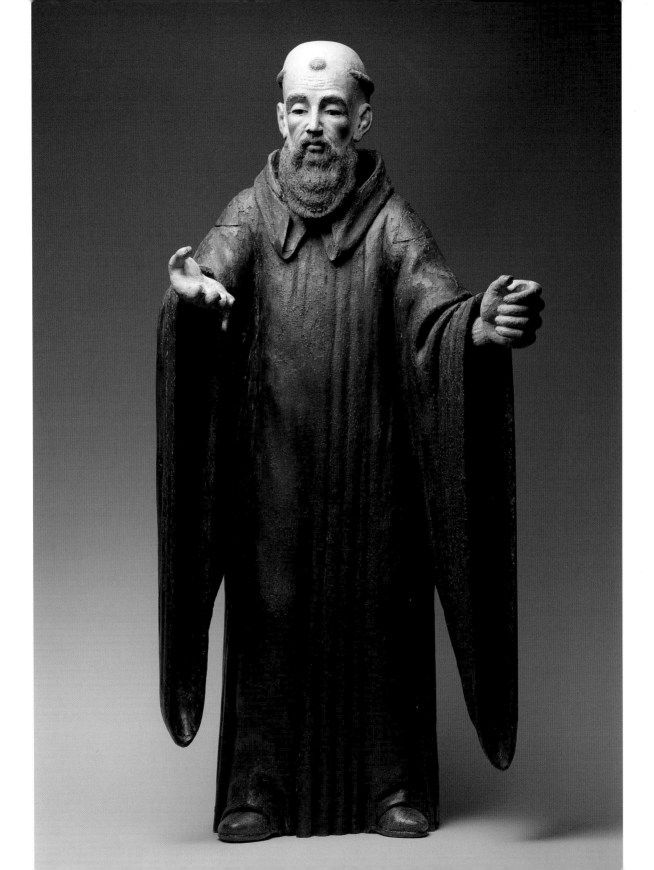

RUDY FERNÁNDEZ

born 1948

Escape

1987, painted wood,
neon, lead, and oil
116.6 x 93.4 x 15.3 cm
Smithsonian
American Art Museum
Gift of Frank K. Ribelin

In *Escape,* Fernández draws upon traditional New Mexican arts to create a mock devotional screen (*reredos*). Along with the *reredos's* architectonic forms and religious imagery, this work includes elements of Pop art and personal symbolism. The altar-like format is crowned with a rigid white trellis, whose repeating diamond and triangle shapes recall motifs found on ancient architecture of the Americas. The neon tubing, however, marks this as a very contemporary work. Throughout this mixed-media construction Fernández presents us with oppositions. Floral motifs and repetitive heart logos are contrasted with a large pushpin and a cactus. A multicolored trout with its mouth agape swims upstream to no avail, for contrary to the work's title, there is no escape. A number of shapes suggest crosses, which Fernández has said "represent the church as it overshadows the Mexican culture."

In 1975, while teaching in Mexico City, Colorado-born Rudy Fernández saw for the first time an exhibition of the works of Frida Kahlo. Frustrated that his formal art education had excluded the arts of Mexico, Central, and South America, he was determined to learn more about what he calls "pre-Cortesian" art. Since then he has developed a personal vocabulary of visual symbols, a unique vernacular that blends Chicano, Mexican, and Anglo artistic and cultural references.

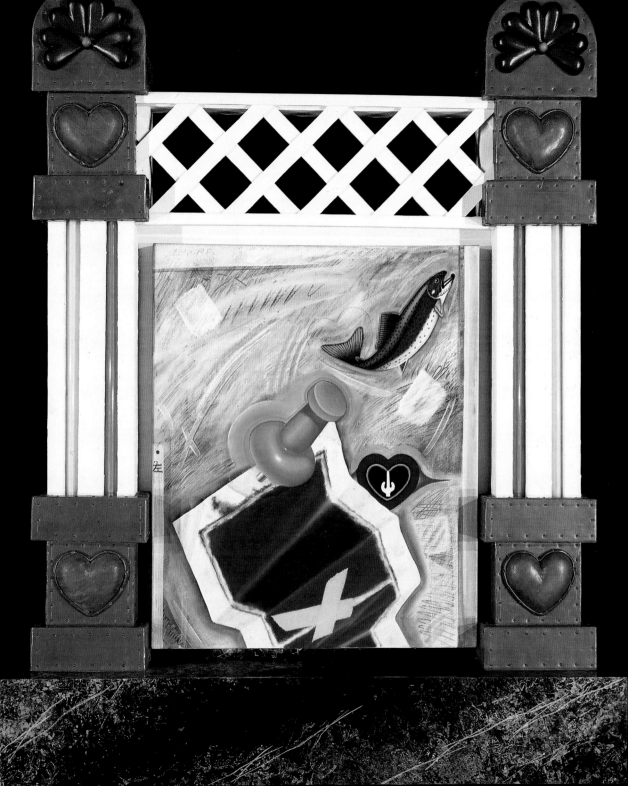

**PEDRO ANTONIO
FRESQUÍS**

1749–1831

Our Lady of Guadalupe

about 1780–1830
painted wood
47.3 x 27.3 x 2.2 cm
Smithsonian
American Art Museum
Gift of Herbert Waide
Hemphill Jr. and
museum purchase
made possible by
Ralph Cross Johnson

In 1531, the Virgin Mary miraculously appeared before a Native American shepherd who had recently converted to Catholicism. She told him to ask the Bishop to erect a church in her honor on the hill of Tepeyac, an ancient Aztec holy site dedicated to the mother goddess Tonantzin. As proof of the Virgin's appearance, she instructed the shepherd to fill his cape with roses from this hill where cacti usually grew. When he emptied the fragrant contents before the Bishop, the onlookers saw the image of a brown-skinned Virgin imprinted on the cloth. The mixing of the former indigenous Aztec goddess and the Catholic saint gave birth to a new cult of the Virgin of Guadalupe.

This delicately painted *retablo* (devotional panel) is attributed to the early New Mexican *santero* Pedro Antonio Fresquís. The Virgin stands atop a dark crescent-shaped moon, surrounded by glowing light called a *mandorla*. Outside this celestial realm the artist embellished the border with his trademark decorative flowers and vine-like designs.

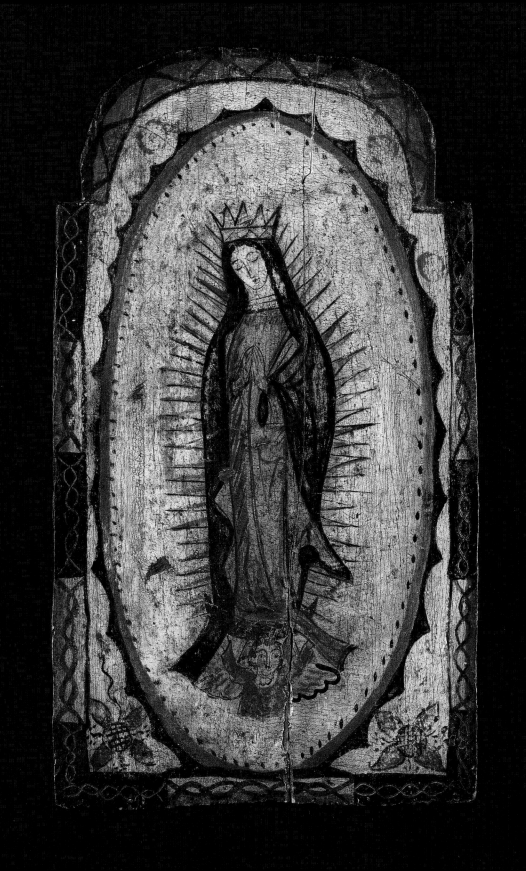

ROBERTO GIL de MONTES

born 1950

Screen

1996, oil
182.9 x 274.3 cm
Smithsonian
American Art Museum
Museum purchase
through the Luisita L. and
Franz H. Denghausen
Endowment

In *Screen* a man poses in front of a green background and gazes at the viewer. His dark hair is neatly combed, his clothing is meticulously pressed—he even wears a necktie—and his face is clean shaven. Since the man is expressionless it is hard to tell what he might be thinking. His features are partially veiled by a thin curtain that is decorated with a floral motif. Gil de Montes prompts us to question the veils we use to shield ourselves from the world.

Originally from Mexico, the artist lived with his family in a number of cities in the United States before feeling conflicted about his cultural identity and returning to his homeland. When he eventually returned to the United States, he began exploring in his artwork issues of identity and place, creating imagery that addressed universal rather than personal conditions.

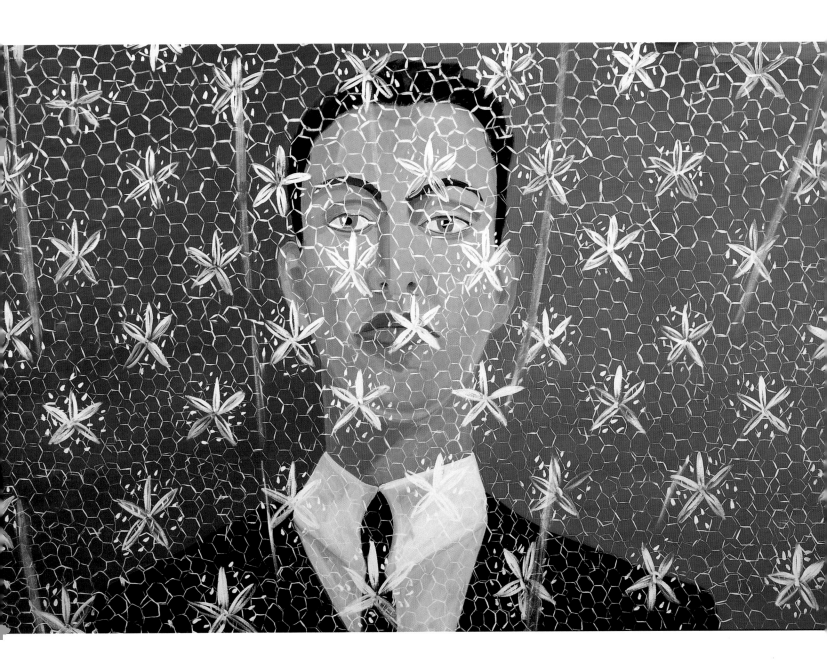

LUIS JIMÉNEZ

born 1940

Man on Fire

1969, fiberglass
269.2 x 203.8 x 75 cm
Smithsonian
American Art Museum
Gift of Philip Morris
Incorporated

Fiery red-orange flames engulf the monumental figure of Cuautémoc, the courageous young ruler who led the Aztecs in revolt against the Spanish conquistadores in the early 1500s. As a result of his rebellion, Cuautémoc was taken prisoner and was tortured by having his feet dipped in oil and set alight. Standing tall and proud, Cuautémoc's brown skin glistens as flames lick the young warrior's body. His left hand is lifted defiantly, becoming one with the billowy flame.

Man on Fire memorializes the disproportionately large numbers of Chicanos who were drafted into the military and sent to Southeast Asia. Jiménez recalls watching television in horror as Vietnamese monks set themselves on fire in protest to the war. The sculpture, on a universal level, serves as a visual symbol of courageous action in the face of oppression.

Luis Jiménez was born in El Paso into a family with a long history of craftsmanship. From his father, who had a business in neon "spectaculars," he established a strong foundation in welding, spray-painting, glassblowing, and tinwork. During a three-month stay in Mexico, which represented for him a pilgrimage to his ancestral home, he turned decisively to figurative art based on subjects from his heritage.

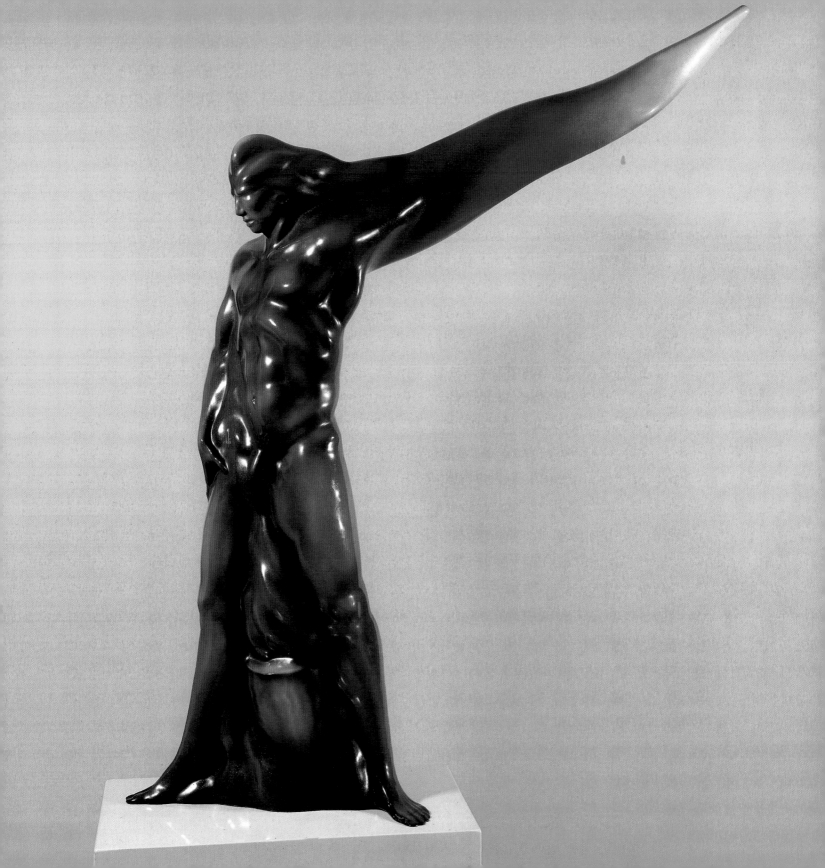

LARES GROUP

active mid-nineteenth–
mid-twentieth centuries

La Virgen y el Niño (Virgin and Child)

about 1875–1900
painted wood with
metal and string
38.3 x 14 x 13.7 cm
Smithsonian
American Art Museum
Teodoro Vidal Collection

In Puerto Rico, ever since the introduction of Catholicism by Spanish colonizers, *santos de palo* (wooden saint figures) have been carved and painted. A particularly expressive style developed in the island's western region of Lares, where figure groups were carved with a lyrical spontaneity, each figure infused with a marked personality. Although known only as the Lares group, since individual artists remain unknown, the style is recognizable by its departure from the baroque naturalism of imported Spanish works.

In *La Virgen y el Niño* (Virgin and Child), an elongated Madonna supports the Christ child on her forearm. Thick grooves in her black hair are echoed in the deep pleats of her flowing robe, which has been stippled with colorful dots. Suspended from her right hand is a *milagro*, an offering left in gratitude for divine intervention, perhaps for relief from a medical ailment. Such Marian devotion continues to flourish in Puerto Rico today.

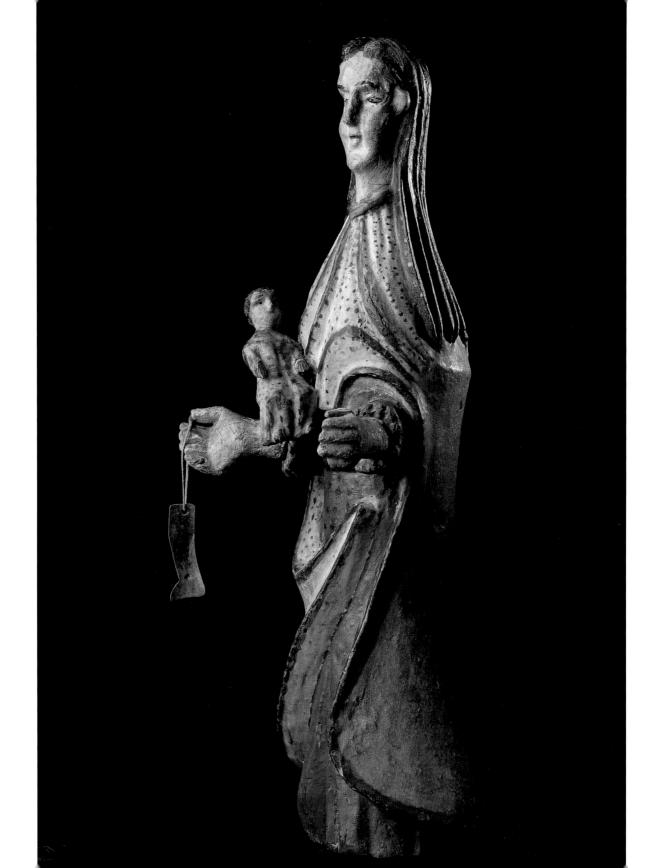

CARMEN LOMAS GARZA

born 1948

Camas para Sueños (Beds for Dreams)

1985, gouache
71.4 x 52.1 cm
Smithsonian
American Art Museum
Museum purchase
through the
Smithsonian Institution
Collections Acquisition
Program

Carmen Lomas Garza is a storyteller. Carmen and her sister are on the roof, looking at the moon and talking about their desire to become artists. It's clear they are close: The young girls share similar hairstyles and clothing—even down to their sandals. The night sky is dark and cloudy, but their shared bedroom glows with light. Blue curtains frame their mother, to whom Lomas Garza dedicated this work. Dressed in a bright yellow patterned dress and crisp apron, she gently snaps the bright red blanket with loving care over the bed in preparation for a night of pleasant dreams.

An accomplished artist and educator, Lomas Garza embraced the Chicano movement for civil rights, dedicating her work to the service of positive social change. She relies on vivid memories of growing up in Kingsville, Texas, to create evocative images that are at once personal recollections and communal remembrances. Often referred to as *monitos,* these delightful works include such daily scenes and festivities as cooking, healing, cakewalks, *lotería* games, and birthday parties.

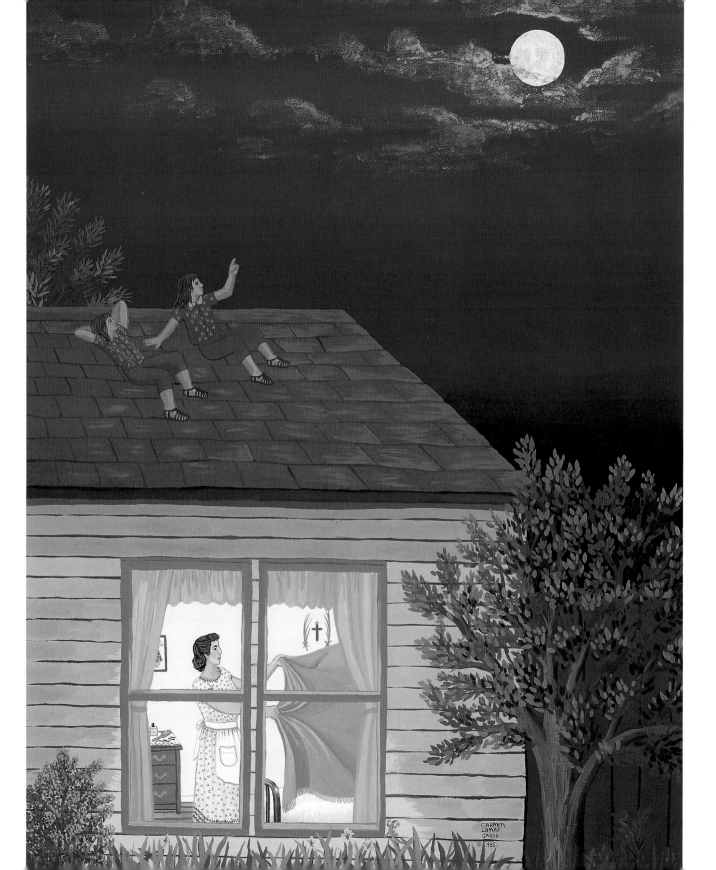

FÉLIX LÓPEZ

born 1942

Nuestra Señora de los Dolores (Our Lady of Sorrows)

1998, gesso, natural pigments and dyes, piñon sap, and gold leaf on pine and aspen 212.1 x 59.7 x 59.7 cm Smithsonian American Art Museum Museum purchase through the Smithsonian Institution Collections Acquistion Program

Félix López was raised in a large, close-knit family in Santa Cruz, New Mexico. When their beloved father died in 1975, the López family arranged for a traditional wake in the meeting house near their home. As he and his family grieved over this difficult loss, López was profoundly affected by seeing his father laid in state surrounded by assorted *santos*. He later remarked, "It moved me so much, culturally, spiritually, that I knew I couldn't be my old self any more." From that point he was inspired to rediscover his cultural heritage and began studying the *santos* tradition. Two years after his father's death, López took up carving. At first he produced small animal sculptures, but soon began carving images of saints.

This elongated figure of the Virgin Mary, her halo radiant with gilding, grieves over the suffering and crucifixion of her son, Jesus Christ. Traditionally, arrows or daggers pierce her heart as a symbol of great pain and sorrow, an image based on a Gospel verse: "Yea, a sword shall pierce through thine own soul also." Here, López departs from tradition by eliminating the arrows from the saint's attributes. Additionally, he produced the elaborate niche in which *"La Dolorosa"* is standing. The harmonious result reflects the artist's deep spiritual and cultural roots.

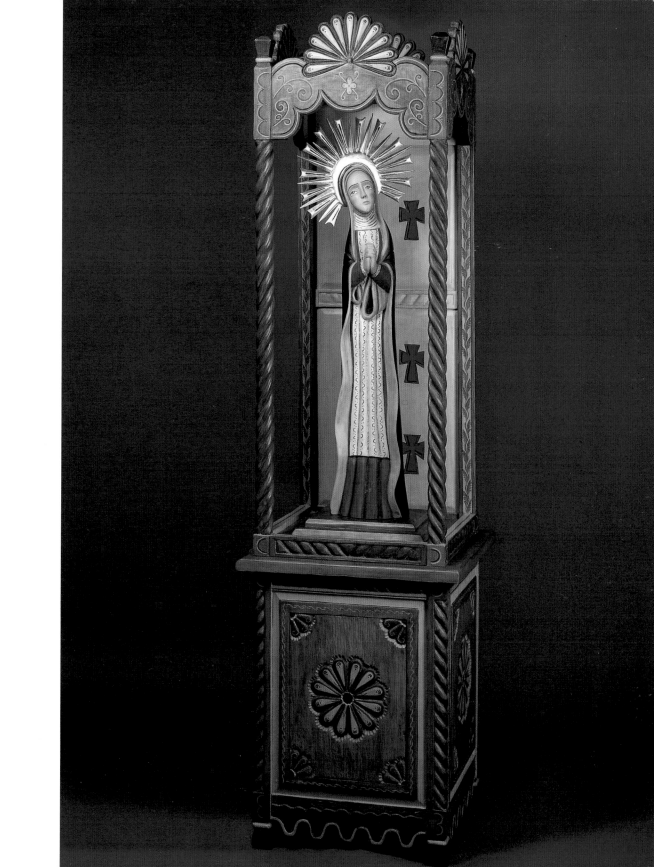

GEORGE LÓPEZ

1900–1993

San Miguel el Arcángel y el Diablo
(Saint Michael the Archangel and the Devil)

about 1955–56, aspen
and mountain mahogany
122 x 83.8 x 100.3 cm
Smithsonian
American Art Museum
Gift of Herbert Waide
Hemphill Jr. and
museum purchase
made possible by
Ralph Cross Johnson

Saint Michael the Archangel is the patron saint of soldiers and protector of the just. He is also Satan's formidable opponent. In this statue Saint Michael has conquered the devil, rendering him immobile. Flat on his stylized wings, he strains upward—to no avail. A long wooden staff has pierced the devil's neck, causing him to grimace in pain. Even his overgrown nails, curved and scythe-like, are of no help to him now.

This animated sculpture was created by George López, one of northern New Mexico's preeminent *santeros*. The artist was taught by his father, José Dolores López, who originated the Córdova style of chip-carved, unpainted statues. George López used a saw, sharp knife, and sandpaper to create this simple yet powerful work, which reveals influences from Roman Catholicism, medieval Spanish art, as well as the *Penitentes* (a religious brotherhood of flagellants). In Córdova, New Mexico, nestled in the 7,000-foot-high valley of the Sangre de Cristo mountains, the artist learned about the lives of the saints in his religious household. He also learned about the devil, which he carved as a half-snake, half-insect-dragon.

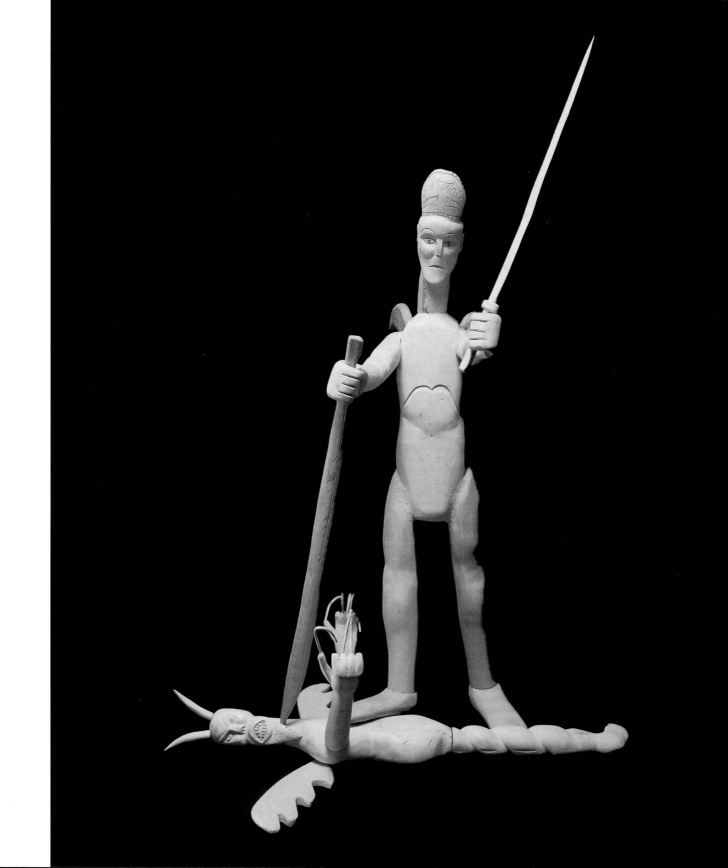

GLORIA LÓPEZ CÓRDOVA

born 1942

Our Lady of Light

1997, aspen and juniper
64.1 x 32.4 x 15.9 cm
Smithsonian
American Art Museum
Museum purchase
through the Julia D. Strong
Endowment

Gloria López Córdova comes from a long line of northern New Mexican carvers. As her respected grandfather José Dolores López, her uncle George López, and other family members have done in the mountain village of Córdova, she uses the chip-carving tradition to express her spiritual and artistic vision.

In *Our Lady of Light,* López Córdova decorates the elaborate crown with diamond shapes and motifs that represent the region's flowers. A decorated arc with nine lighted candles echoes the shape of the large crown, with its alternating triangles and finials carved from light-colored aspen and dark-colored juniper. Deeply incised chip carving and intricate patterns unify the work, including the sturdy circular base on which *Our Lady of Light* stands. The saint's hands and head are simply treated, her hair a ribbon-like pattern, and her face a combination of abstract shapes and forms.

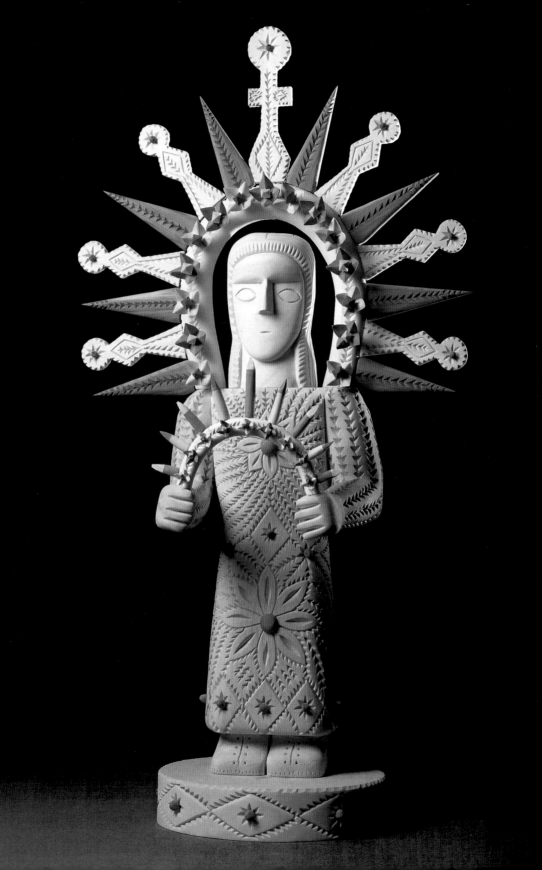

MARTINA LÓPEZ

born 1952

Heirs Come to Pass, 3

1991, silver-dye
bleach print made
from digitally
assisted montage
76.2 x 127 cm
Smithsonian
American Art Museum
Gift of the Consolidated
Natural Gas Company
Foundation

Martina López uses old family photographs to create a collective history that not only allows her to express feelings of loss, but also provides a visual terrain in which viewers are able to insert their own ancestral memories. In *Heirs Come to Pass, 3,* Victorian formality meets desolation and ambiguity in a surreal dream world.

RAMÓN JOSÉ LÓPEZ
born 1951

Liturgical Cross

1998, silver, mica, and
pigment on wood
89.6 x 63.2 x 5 cm
Smithsonian
American Art Museum
Museum purchase
made possible
by William T. Evans

On the front of this *Liturgical Cross* is the crucified Christ, and on the back is Saint Francis, complete with stigmata. López used mica crystal sheets as a thin glazing material; silver tacks hold the mica and silver framing to the painted wood support. In the style of early Colonial Mexican silverware ornamentation, rays emerge from the right angles formed by the arms of the cross, adding a dazzling glint that contrasts with the solemnity of the crucified Christ.

New Mexico artist Ramón José López worked for a few years in construction before beginning his career as a jeweler and silversmith. The grandson of noted *santero* Lorenzo López, he uses many of his grandfather's tools in his work. Ramón López has said, "My traditional work [lets] me see how influenced I really was by my heritage, my history. It showed me my roots [and] . . . opened my eyes. I want to achieve the level . . . of those old masters . . . what they captured . . . emotions, so powerful, so moving." López researches traditional methods and materials and masters them in his contemporary silver and gold jewelry, hollowware, painted hides, *reredos, escudos* (reliquaries), and blacksmithing. In addition, he also produces ecclesiastical vessels, chalices with patens, pyxes, rosary boxes, furniture, and architectural elements.

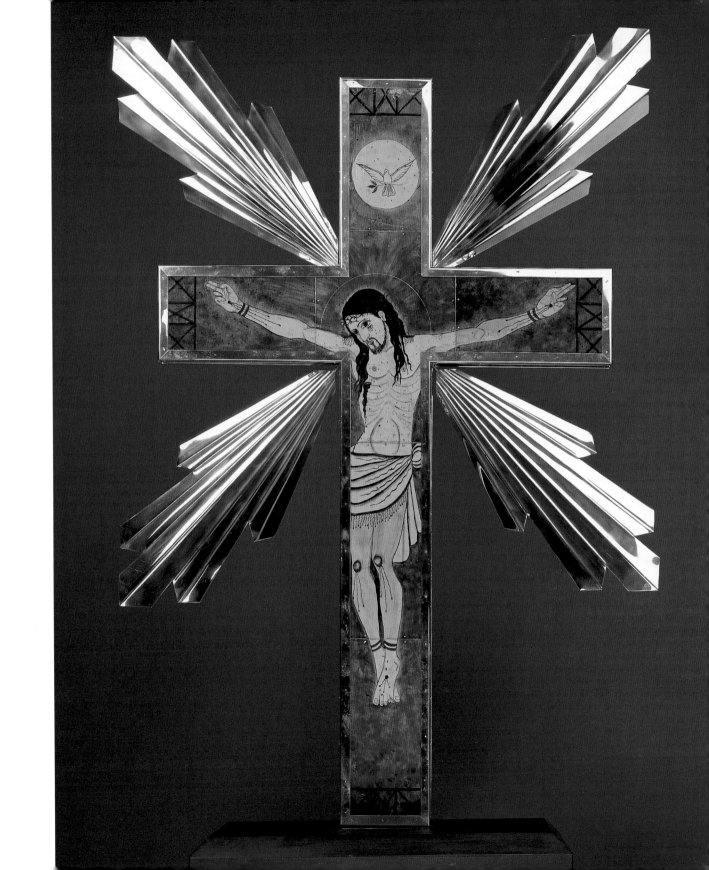

Tapestry Weave Rag Jerga

1994, woven cotton
cloth on cotton
yarn warp
219.7 x 133.4 cm
Smithsonian
American Art Museum
Museum purchase
in part through the
Smithsonian Institution
Collections Acquistion
Program

Born in 1898, Agueda Martínez learned to weave from her uncle, Lorenzo Trujillo, first weaving rag rugs when she was twelve, and later weaving tapestry wool blankets. From 1925 until her death at 102, she lived and worked in Mendanales, New Mexico, not far from Santa Fe, where she carried on textile traditions that had been in her family since the sixteenth-century Spanish conquest. Martínez's vibrant works blend Pueblo and Navajo with early Spanish and north Mexican textile traditions. In addition to working daily at her treadle loom, the artist also bore ten children. Agueda Martínez passed on the weaving tradition by teaching through the Home Education and Livelihood Programs (HELP) in Hernández and Abiquiu, New Mexico.

Agueda Martínez kept beautiful gardens, often using her plants and flowers as dyes for her wool. Here the juxtaposition of reds and greens, complemented by bright yellows, lavenders, and earth tones, create a stunning textile. Martínez called this magnificent work a *jerga* (floor-cloth) because of its coarse weave, resulting from her unique method of weaving yarn from strips of recycled T-shirts. An artist who inspired others, Doña Agueda was rightfully proud in stating, "There's no one that can beat me at weaving."

EMANUEL MARTÍNEZ

born 1947

Farm Workers' Altar

1967, acrylic on
mahogany and plywood
96.9 x 138.5 x 91.4 cm
Smithsonian
American Art Museum
Gift of the International
Bank of Commerce
in honor of Antonio R.
Sanchez Sr.

On March 10, 1968, civil rights leader César Chávez broke a twenty-five day fast at this wooden altar. In the grape fields near Delano in central California, many supporters celebrated the Mass with Chávez. He had fasted to protest the deplorable working and living conditions of migrant farm workers, and his struggle on their behalf was joined by many civil rights advocates and political leaders.

Chicano artist Emanuel Martínez was about twenty when he created this altar to commemorate the workers' cause. Perfectly formed grape clusters evoke the fruit that still today is boycotted by many Latinos as a symbol of conditions that inspired the farm workers' movement. On one side of the altar four hands of various shades grasp the vines—a symbol of unity, strength, and dignity in labor. Their secure grasp repeats the hands of the crucified brown-skinned Christ on an adjacent panel. A stylized black eagle flies proudly in front of an emblazoned red circle, the symbol of the United Farm Workers, the union that César Chávez founded with Dolores Huerta and others. On another side, a woman holds grapes in her left hand and corn in her right. Around her neck she wears a peace sign, in keeping with Chávez's practice of nonviolence. Overhead a large round sun contains a significant cultural icon: the *mestizo* tripartite head, a powerful symbol of the mixed heritage of many migrant workers.

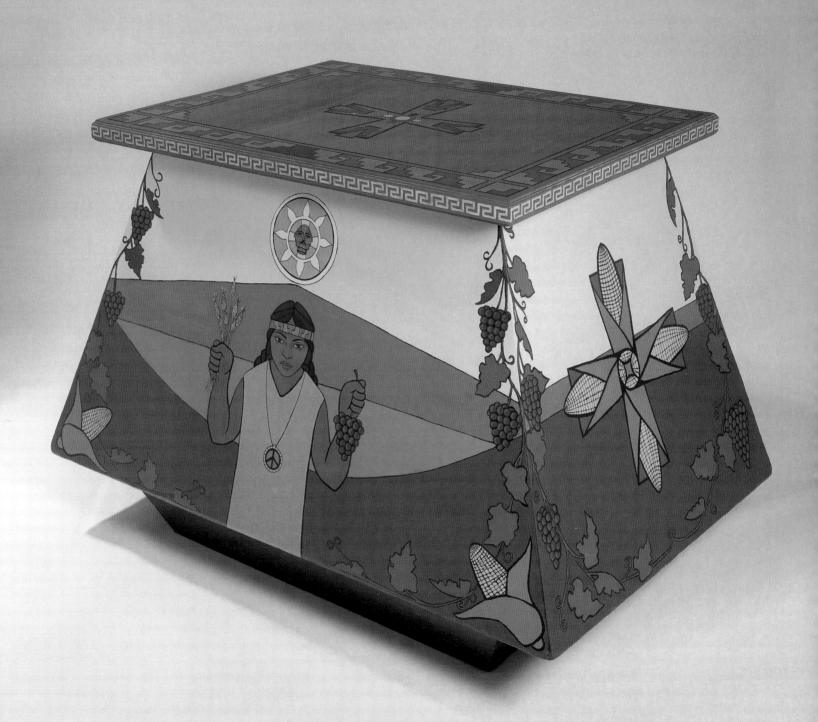

MARÍA MARTÍNEZ-CAÑAS

born 1960

Totem Negro XVI

1992, silver print
135.9 x 23.8 cm
Smithsonian
American Art Museum
Museum purchase
through the Smithsonian
Institution Collections
Acquisition Program

When María Martínez-Cañas was three months old, her family emigrated from Cuba to Puerto Rico in the wake of Castro's political revolution. She developed an early "child-curiosity" with cameras and eventually she studied photography in Philadelphia and Chicago. In 1985, Martínez-Cañas received a Fulbright-Hays grant to study in Spain for six months, exploring Cuban maps from the sixteenth through eighteenth centuries that recorded Spanish explorations of the strategically positioned island. The trip had a profound and lasting influence on her work, as she explains: "For the last few years my work has dealt with the search for a personal identity . . . the daily life of Cuban culture before the revolution, family stories, memories of Cuba where I was born but have no recollection of. After a while, I find myself with a terrible need of discovering, on my own, that which has been so unknown for so long. I am dealing . . . with a terrible sense of . . . separation, and alienation. I have always experienced a desire to belong to a 'particular place.'"

In *Totem Negro XVI,* carefully collaged signs and symbols give visual form to Martínez-Cañas's feelings about being an exile. These fragments of ancient manuscripts, postage stamps, geographic forms, pre-Columbian temples, and maps reflect her struggle to reclaim her Cuban heritage. The collaged geometric and organic shapes are scratched and drawn upon before being adhered to sheets of clear plastic that serve as handmade "negatives." Martínez-Cañas then prints a limited edition of contact prints on black-and-white photographic paper.

Untitled from the "Silueta" series

1980, photograph
98.4 x 133.4 cm
Smithsonian
American Art Museum
Museum purchase
in part through the
Smithsonian Institution
Collections Acquisition
Program

Ana Mendieta was a sculptor, and a performance and conceptual artist. She was born in Havana, Cuba, and came to the United States in 1961, when many Cubans were fleeing Fidel Castro's regime. Mendieta and her sisters were raised in different orphanages and foster homes in Iowa. Although she eventually studied at the Center for the New Performing Arts at the University of Iowa in Iowa City, she always considered herself an artist in exile.

Mendieta often used her body as a template for silhouettes shaped in mud. Carving directly into the clay bed, she reestablished connections with her ancestors and ancestral land. This female contour inscribed in the earth recalls earth goddesses of ancient cultures, reflecting Mendieta's feminist stance. The art of carving provided Mendieta with a link to the past, a renewed sense of power in the present, and a bond to the timeless universe. As she remarked poetically, "I have thrown myself into the very elements that produced me, using the earth as my canvas and my soul as my tools." She made this photograph as a record of her ephemeral sculpture.

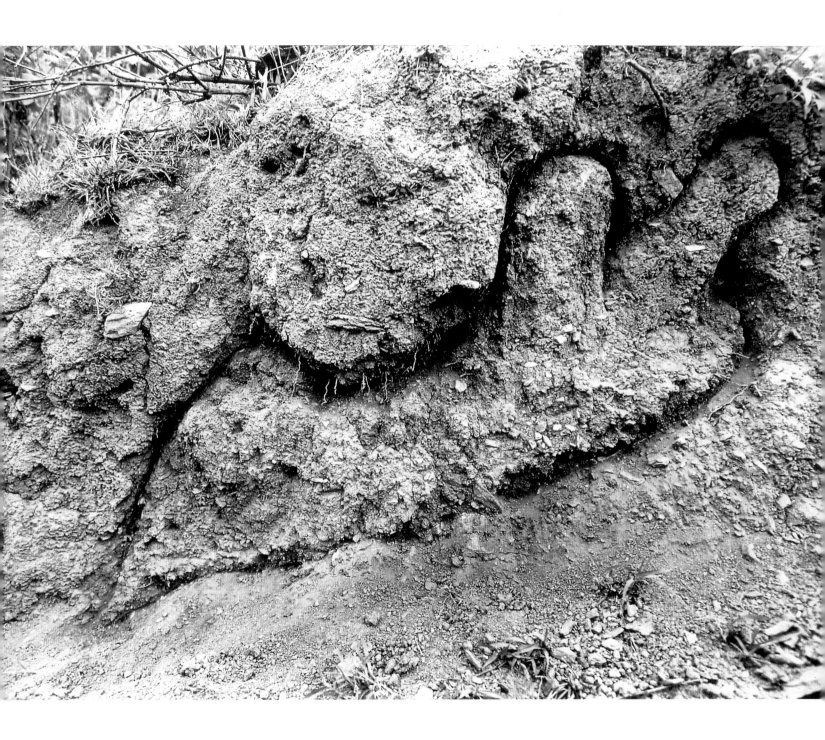

AMALIA MESA-BAINS

born 1943

An Ofrenda for Dolores del Rio

1984, mirror on plywood,
cloth, and found and
handmade objects
369.2 x 184.6 x 123 cm
Smithsonian
American Art Museum
Museum purchase
through the Smithsonian
Institution Collections
Acquisition Program

Amalia Mesa-Bains has written, "In modern times the cinema has been the moving force in promoting the myth of female beauty. Among its creations have been Marlene, Marilyn, Greta and the great Mexican beauty, Dolores del Rio."

Here Mesa-Bains pays homage to the beloved film star, often cast as the "exotic" woman. Long swags of silk and taffeta puffs hang above the altar, while a delicate lace drapes the niche containing a photograph of the star that takes center stage atop the mirrored pedestal. Four photographs on each side of the altar further frame del Rio in the context of several of her films. Dried flowers and confetti are strewn on and around the mirrored altar, reflecting a feminine quality in the installation, while perfume bottles, an open fan, and jewelry are juxtaposed with Mexican and Chicano bric-a-brac, linking personal effects with cultural symbols. The overall image of this lavish offering is one of glamour, elegance, and reverence. Dolores del Rio gave Chicanas an alternative to the Anglo-American standard of beauty. She refused to be cast as a sexy Mexican "spitfire," and instead brought a dignity to each character she portrayed. As with some other *altaristas*—artists who use the altar form—Mesa-Bains uses a religious cultural form to comment on a secular theme.

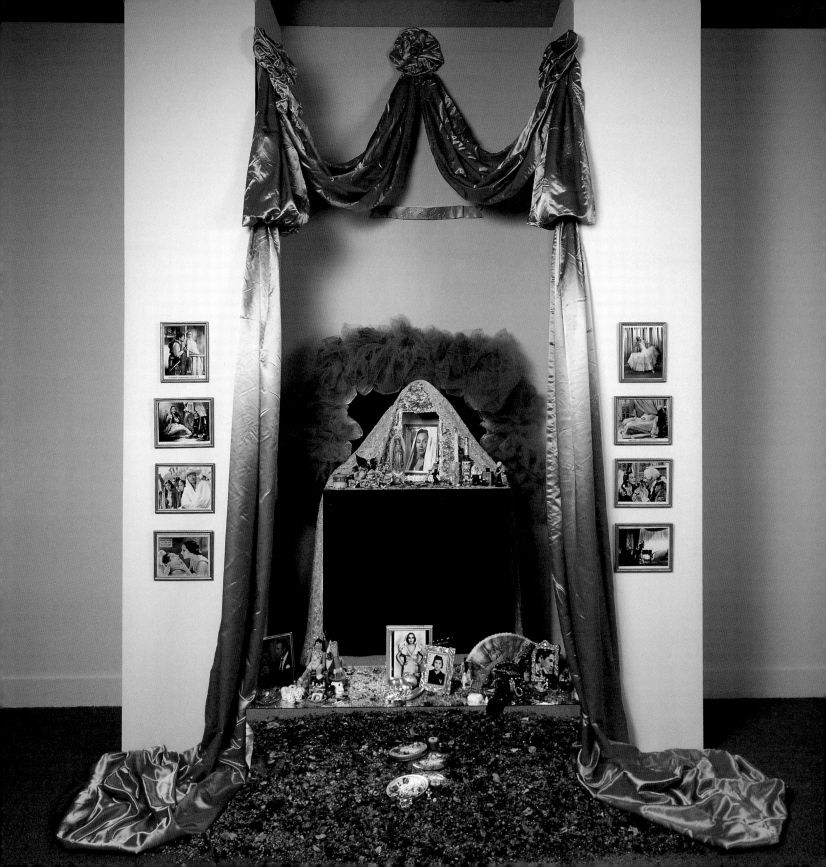

DELILAH MONTOYA

born 1955

Los Jovenes (Youth)

1993, collotype
20.3 x 25.4 cm
Smithsonian
American Art Museum
Museum purchase
made possible by the
Horace W. Goldsmith
Foundation

As a photographer, printmaker, and installation artist, Delilah Montoya likes to work in collaboration with her community. In this graffiti-filled room, eight youths stand within an altarlike tableau, complete with candles and a *Virgen de Guadalupe* on the back wall—a protectress floating above the figures. One *joven* poses in profile, his foot resting on a basketball, a symbol of his youth.

Montoya used a nineteenth-century collotype technique in which the negative is inked and printed, a process that blends photographic documentation and manipulation. *Los Jovenes* is part of a series entitled *El Corazón Sagrado* (The Sacred Heart), a religious and cultural symbol that blends European Catholicism and Aztec philosophy. According to Chicano art scholar Dr. Tomás Ybarra-Frausto, "the heart has served as a symbol of resilience, bound both to visual iconography and to the process of creation itself." In this heartfelt work, Montoya has created a striking image of family strength—and love.

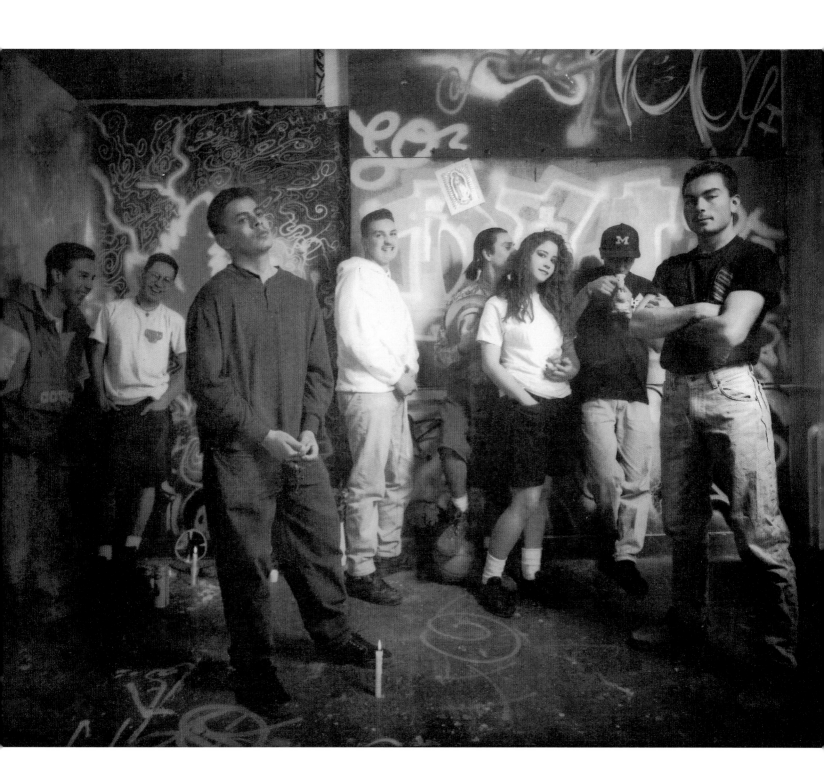

ABELARDO MORELL

born 1948

Camera Obscura Image of Manhattan: View Looking West in Empty Room

1996, silver print
74.9 x 100.3 cm
Smithsonian
American Art Museum
Gift of the Consolidated
Natural Gas Company
Foundation

Abelardo Morell was born in Havana. As a child he felt a sense of alienation and isolation in Cuba, feelings that remained when he moved as a teenager with his family to New York City. Although he later studied comparative religion at Bowdoin College, he eventually took up photography as a way to express his feelings as an immigrant to the United States during the turbulent 1960s.

In this curious photograph the New York skyline is turned upside down. As the dense cityscape fills the room—empty save for the ladder and the electric cord—the effect is disorienting yet poetic. To achieve this effect, Morell used an old imaging process in a new way: He literally turned the entire room into a camera. Use of the camera obscura— literally "dark room"—dates to the seventeenth century, well before the advent of conventional photography. Morell covered the windows in the empty room with black plastic, into which he cut a small hole to serve as the "camera's" aperture. As light entered from the outside, it projected onto the opposite wall an inverted image of Manhattan. On the wall near the aperture the photographer placed a large-format camera on a tripod—in effect, placing a camera within a camera. After an exposure of about eight hours this image was produced. The result is an eerie juxtaposition of an interior/exterior, an ambiguous new image that serves as a metaphor for private and public life.

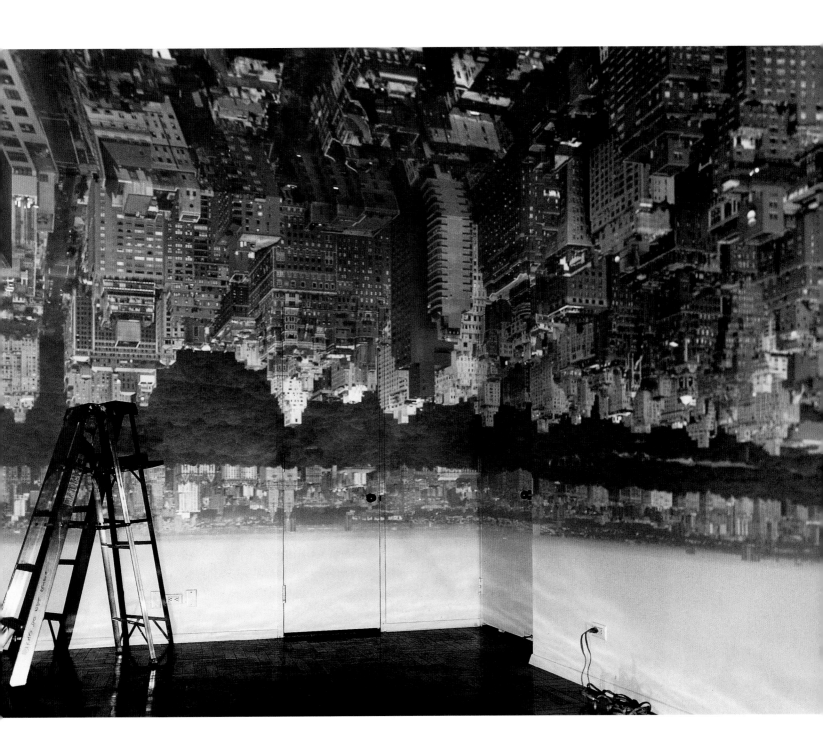

JESÚS BAUTISTA MOROLES

born 1950

Georgia Stele

1999, granite
208.3 x 31.1 x 20.3 cm
Smithsonian
American Art Museum
Gift of the artist

Light and shadows dance across the mineral-encrusted surfaces of *Georgia Stele,* accentuating its height and geometric forms. In his desire to push the limits of the unforgiving granite, Moroles worked the stone in a way that recalls ancient indigenous stele—upright stone slabs engraved with historical inscriptions, such as those found in the early Mayan cities in the jungles of southern Mexico and northern Guatemala. This commanding sculpture is punctuated with long vertical spaces that give way to an energetic, unpredictable rhythm of squares and rectangles, suggesting a more modern influence, perhaps the ubiquitous skyscrapers of the American metropolis.

In boyhood and young adult life, Jesús Bautista Moroles worked during the summers with an uncle in Rockport, Texas, where he gained a strong foundation in stonemasonry. A series of courses taken at North Texas State University strengthened these skills. During 1980 the artist worked in a foundry at Pietrasanta, Italy, learning European sculpting techniques. On his return to Texas, Moroles started producing monumental granite sculpture for which he is well known today.

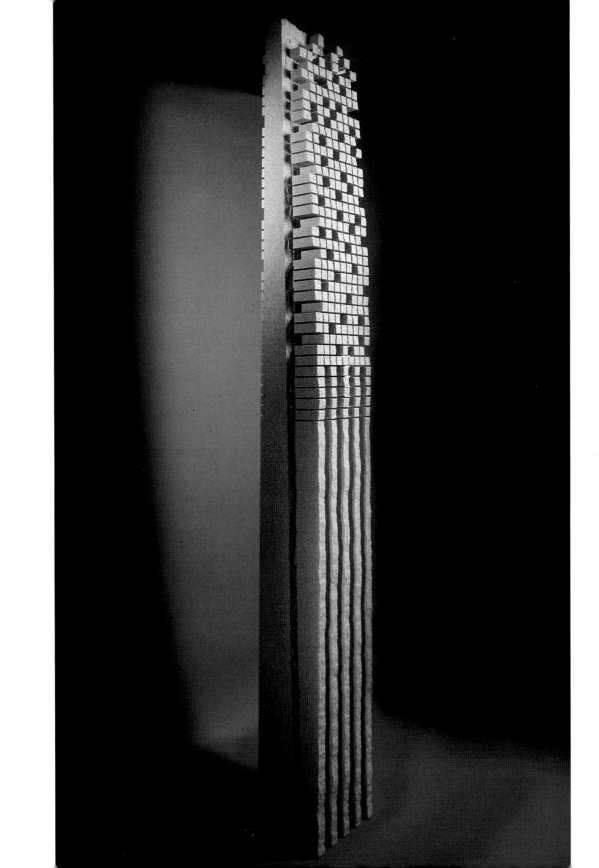

"Sugar Children" series

1996, silver prints
each 35.6 x 27.9 cm
Smithsonian
American Art Museum
Museum purchase
made possible by the
Horace W. Goldsmith
Foundation

Big James Sweats Buckets

Jacynthe Loves Orange Juice

Little Calist Can't Swim

Valicia Bathes in Sunday Clothes

Brazilian-born Vik Muniz used granulated sugar on black paper to portray the children of sugarcane workers whom he met on St. Kitts, one of the Leeward Islands ringing the Caribbean. After each image was "drawn" he photographed it and then wiped the background paper clean of its sugary medium in preparation for the next. Blended with these faces is a socially critical message, for each print represents the island sugar trade in both subject and medium. The sugar represents "the sweetest group of human beings" Muniz ever met. By wiping away the residue, he symbolically erases history only to replace it with a new image—suggesting that life and work on the sugar plantations is cyclical, intergenerational, and unending.

"The power of the image lies in its ability to be underestimated. They're sweet simple things. You think you know what you're looking at," says Muniz, who wants the viewer to look anew at representation. These prints ask the eye to question what it sees, posing a relationship between reality, truth, representation, and memory.

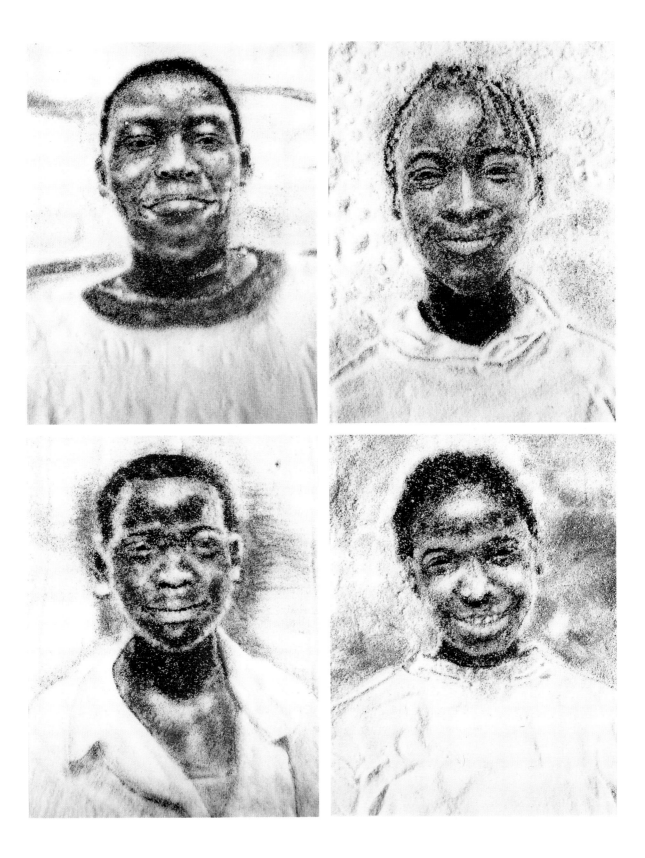

JOSÉ BENITO ORTEGA

1858–1941

Our Father Jesus of Nazareth

about 1885
painted wood and
cloth with leather
76.2 x 23.8 x 23.8 cm
Smithsonian
American Art Museum
Gift of Herbert Waide
Hemphill Jr. and
museum purchase
made possible by
Ralph Cross Johnson

José Benito Ortega was born in La Cueva, New Mexico, and began making *santos* at an early age. From the 1870s to the early 1900s, he traveled throughout Northern New Mexico making images of saints. During his lifetime he created innumerable works for chapels, meeting houses, homes, and for the brotherhood of flagellants called the *Penitentes.*

Ortega carved *Our Father Jesus of Nazareth* from boards discarded by lumber mills, which explains its flatness. The figure's small size and supporting wooden slats suggest that it was dressed and carried in Holy Week processions, probably by members of the *Penitentes.* These supporting slats—which helped to stabilize the figure as it was carried— would normally be concealed under a garment when the figure was dressed. Ortega's works are said to resemble the people whom the artist used as models. This powerful image successfully conveys Christ's suffering through the downcast eyes, solemn face, exposed palms, and the graphic representation of bleeding. Ortega was among the early itinerant artists working when mass-produced plaster statues began replacing traditional, hand-carved *santos.* Shortly after 1907, Ortega stopped carving.

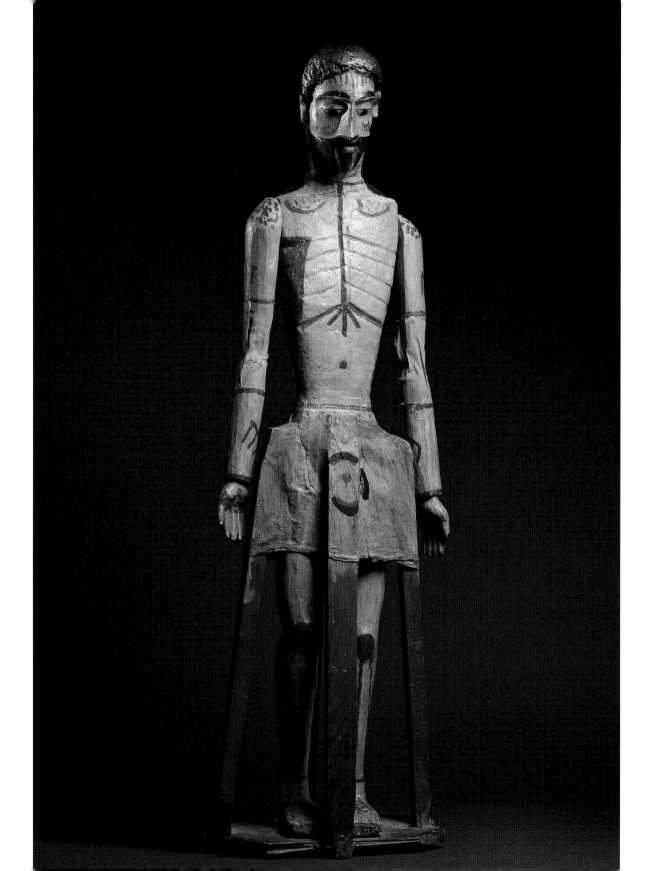

PEPÓN OSORIO

born 1955

El Chandelier

1988, chandelier
with found objects
154.6 x 106.7 cm diam.
Smithsonian
American Art Museum
Museum purchase
in part through the
Smithsonian Institution
Collections Acquisition
Program

Born in San Juan, Puerto Rico, Pepón Osorio has childhood memories of the island that include helping his mother decorate elaborate cakes for community celebrations and marveling at his sister's abundant jewelry.

Much later, walking through Spanish Harlem and the South Bronx where he now lives, Osorio noticed that nearly every apartment had a chandelier. For the artist, these "floating crystal islands" are symbols of cultural pride in Puerto Rican neighborhoods. *El Chandelier* is fantastically—indeed, excessively—decorated with swags of pearls and mass-produced miniature toys and objects, including palm trees, soccer balls, Afro-Caribbean saints, cars, dominoes, black and white babies, giraffes, and monkeys. The objects are metaphors for the immigrant popular culture of the 1950s and '60s, when islanders moved to the U.S. mainland in significant numbers. At night the chandelier sparkles and, as a child once suggested, the multifaceted crystals recall the tears of the community.

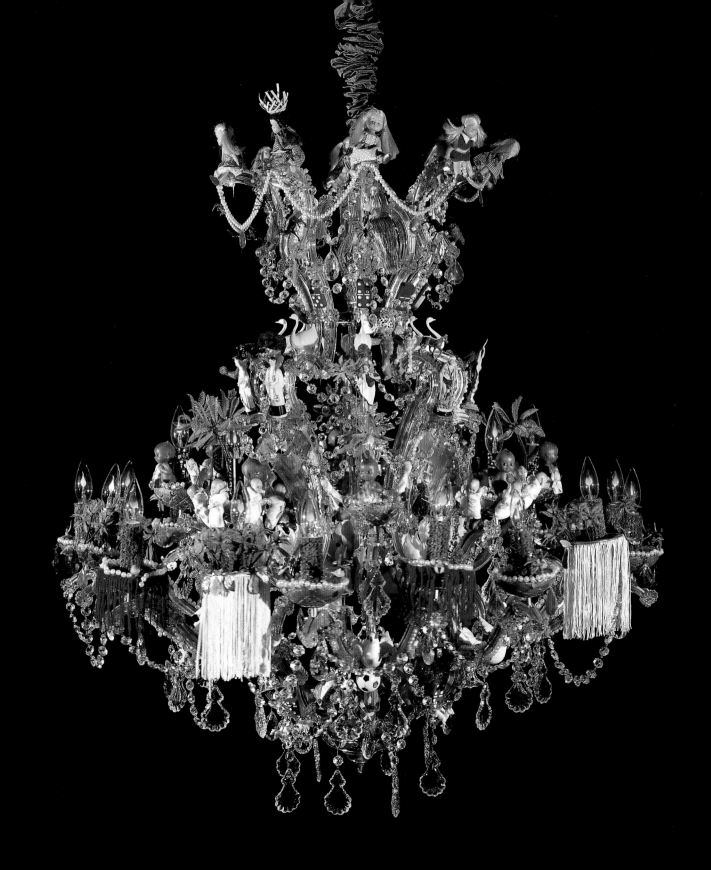

JOSEPH RODRÍGUEZ

born 1951

Mothers on the Stoop

1988, chromogenic
photograph
45.7 x 30.5 cm
Smithsonian
American Art Museum
Gift of the artist

Joseph Rodríguez was shy as a child, so discovering photography was a revelation, becoming a way for him to communicate. To get close to his subjects, he spends a lot of time with them. "The only way to get a really good photograph is by listening to people," says Rodríguez, who believes that listening is often more important than taking the photograph. As he has also stated, "I feel very rich when I see pictures with emotion in them that I've created. That's my big pay back. It's very personal."

In this lush chromogenic photograph, Rodríguez captured a moment in the lives of four Puerto Rican mothers and their children. This image is part of a large documentary project, in which Rodríguez took seven hundred rolls of film during four years to capture the story of Spanish Harlem, a traditional Puerto Rican neighborhood in New York. The series captured what the artist refers to as "the drama of a rich community."

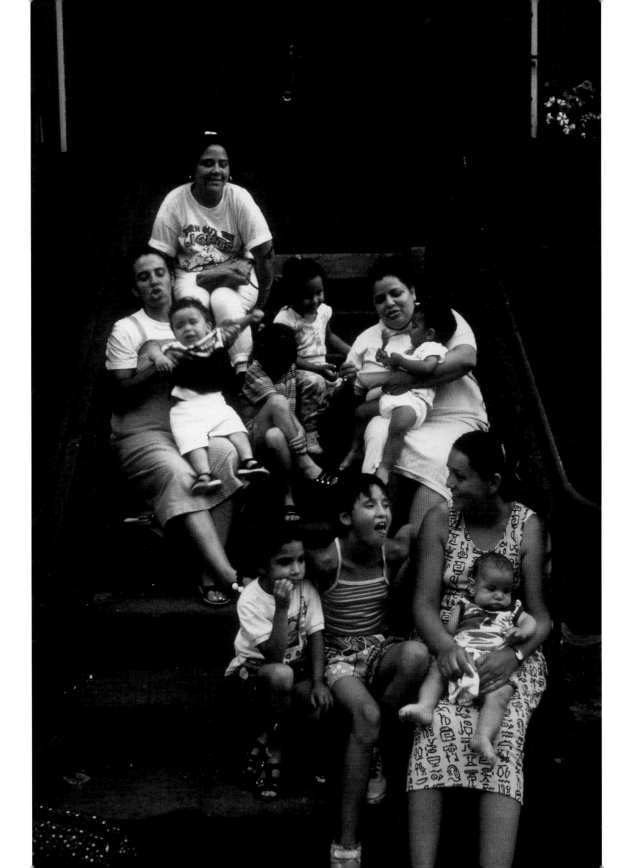

ANGEL RODRÍGUEZ-DÍAZ

born 1955

The Protagonist of an Endless Story

1993, oil
182.9 x 147 cm
Smithsonian
American Art Museum
Museum purchase
in part through the
Smithsonian Institution
Collections Acquisition
Program

The "protagonist of an endless story" is Sandra Cisneros, an acclaimed Chicana author of poetry and fiction. Standing against a dramatic sky, Cisneros strikes a confident pose. She is dressed in a black Mexican dress that is decorated with sequins and embroidery, and holds a patterned rebozo (shawl) that snakes around her bejeweled arms. The main character in this visual drama, Cisneros is "nobody's mother, and nobody's wife," as she stated in the author's note in her acclaimed novel, *The House on Mango Street*. However, unlike Esperanza Cordero, the young protagonist of Cisneros's book who grew up on Mango Street—"a desolate landscape of concrete and run-down tenements"—in this large canvas the author is firmly planted among healthy vegetation that climbs towards an emblazoned sky and presses against the painting's edges.

Although she grew up in Chicago, Cisneros often visited her grandmother in Mexico City. Today she lives in the San Antonio "borderlands," as does the Puerto Rican artist, Angel Rodríguez-Díaz.

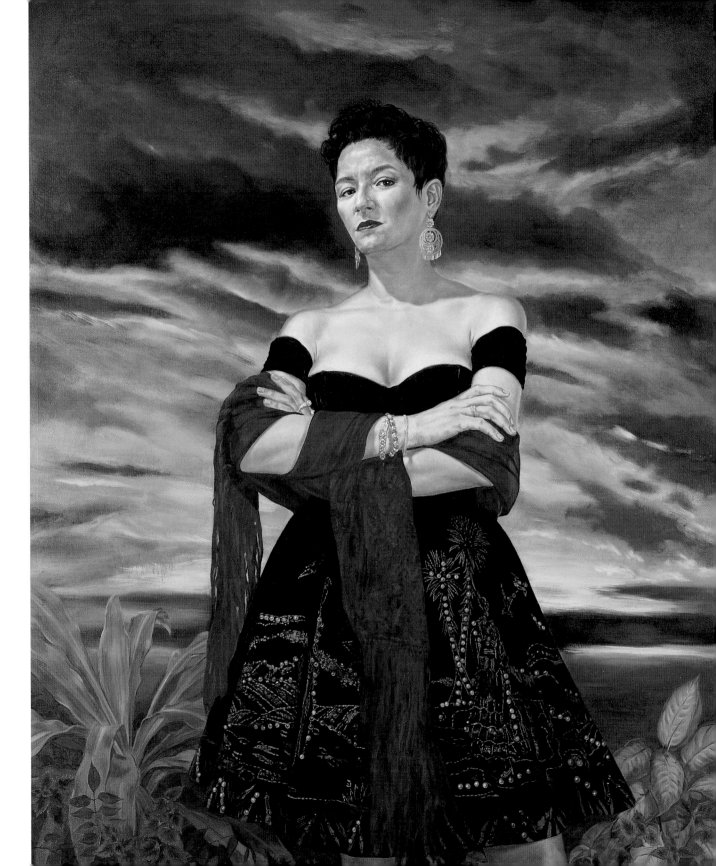

FRANK ROMERO

born 1941

Death of Rubén Salazar

1986, oil
183.5 x 305.8 cm
Smithsonian
American Art Museum
Museum purchase
made possible in part
by the Luisita L. and
Franz H. Denghausen
Endowment

On August 29, 1970, Rubén Salazar was killed when he was struck in the head by a tear gas canister that Los Angeles County sheriff deputies fired into the Silver Dollar Bar. Nearby, an anti–Vietnam War demonstration was taking place as part of the Chicano Moratorium. Salazar was a writer for the *Los Angeles Times* and a television and radio journalist who was often outspoken on issues of racial injustice.

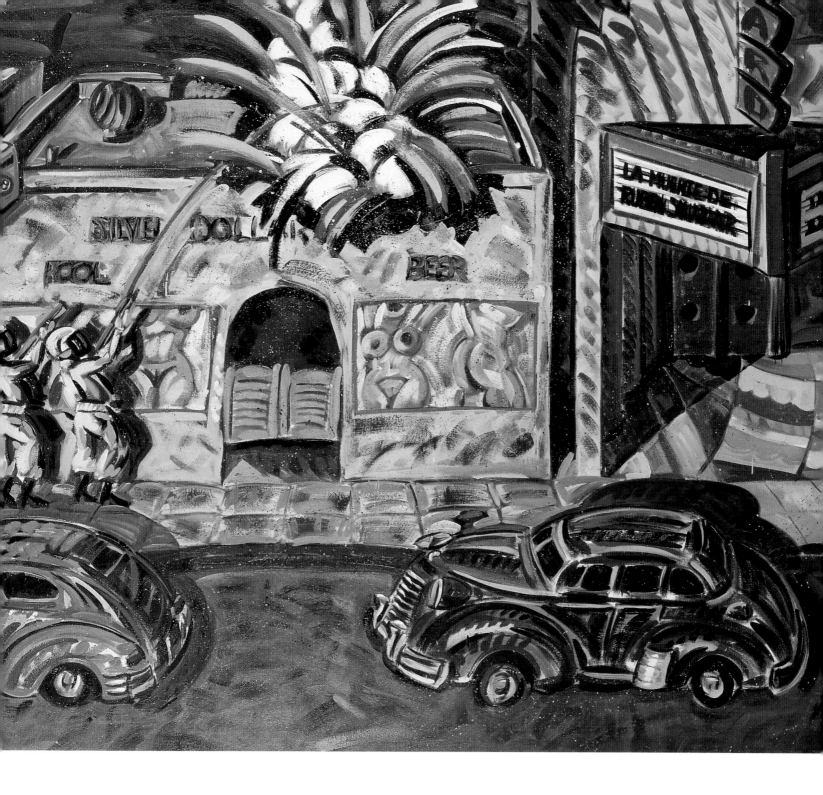

PAUL SIERRA

born 1944

Sinews

1993, oil
184.2 x 256.2 cm
Smithsonian
American Art Museum
Museum purchase
through the
Catherine Walden Myer
Endowment

At the age of sixteen, Havana-born Paul Sierra moved to Chicago, where he studied at the Art Institute. Although a longtime resident of the Windy City, Sierra's tropical palette is based on childhood memories of Cuba. His trademark vibrant colors provide what has been called a "cultural corridor" between his turbulent Cuban heritage and his adopted country.

In *Sinews* an indistinguishable figure appears bogged down in a swamp filled with wild reeds and thick, swirling color. A layer of bright yellow and white supports the shadowed figure, forming a protective light that counters the murky water and blue-black sky in the distance. Sierra's expressionistic brushwork further animates the surface, while the angled perspective adds intrigue, mystery, and a foreboding element to the theatrical scene. At right, a bundle of sinews struggles as though locked in an erotic embrace, the tendons suggesting muscular power and force. There is hope for escape, however, through the long branches near the figure's right hand. This lone figure in a primal landscape represents humanity's constant struggle against and triumph over forces of nature.

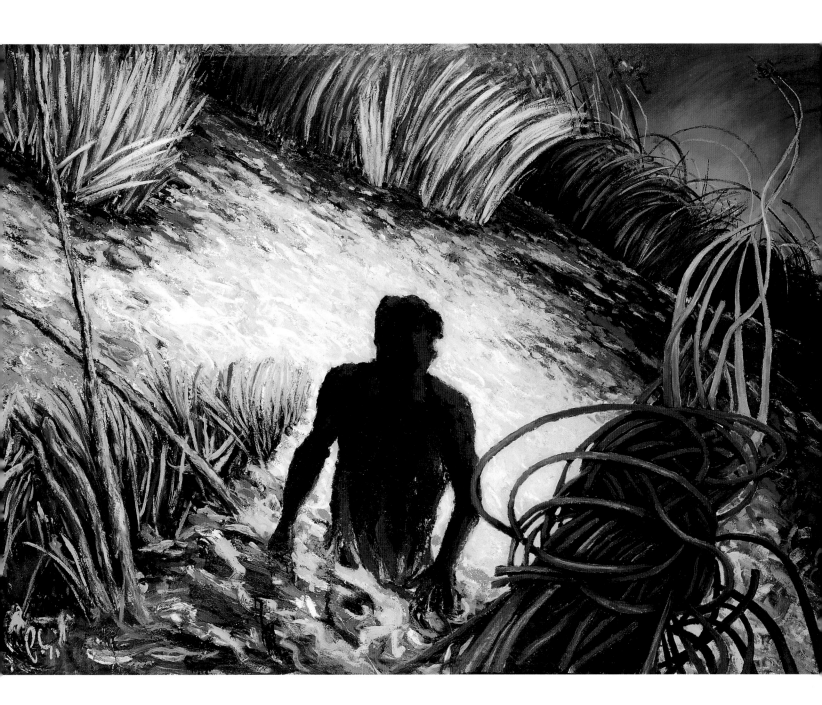

LUIS TAPIA

born 1950

Death Cart

1986, aspen with
mica and human hair
and teeth
130.2 x 81 x 137.2 cm
Smithsonian
American Art Museum
Museum purchase
made possible by
Mrs. Albert Bracket,
John W. de Peyster, and
Mrs. Herbert Campbell

The angel of death—*El Angel de la Muerte* or *Doña Sebastiana*—is usually shown in the form of a woman's skeleton. Sometimes she is borne on a cart, with a hatchet, club, or bow and arrow in her hand. In former times, death carts played an important role in the *Penitentes* sect. As an act of self-mortification, on Good Fridays the *carreta de la muerte* was loaded with heavy rocks and drawn by a hooded supplicant to a site representing Calvary. Along the way, the devoted volunteer would flagellate himself with a horsehair whip or rawhide rope.

Tapia retains some traditional elements, while using artistic license. *Doña Sebastiana*'s bony hands are empty and her fleshless face is animated by her tongue that sticks out in front of real teeth. Other animating features are her deep round sockets that glitter from their micaceous eyes, and actual hair, composed of a gray forelock and long, black braided ponytail.

A native of Santa Fe, New Mexico, Luis Tapia is a self-taught, contemporary artist. Like many in his generation who grew up during a time of cultural homogenization—as well as the emergence of movements for civil rights and social consciousness—Tapia was determined to learn more about his culture. He began carving *santos*, studying them in churches and in the collections at the Museum of International Folk Art in Santa Fe. Around the same time, he helped found La Confradia de Artes y Artesanos Hispanicos, which has been instrumental in the contemporary revival of Southwest art.

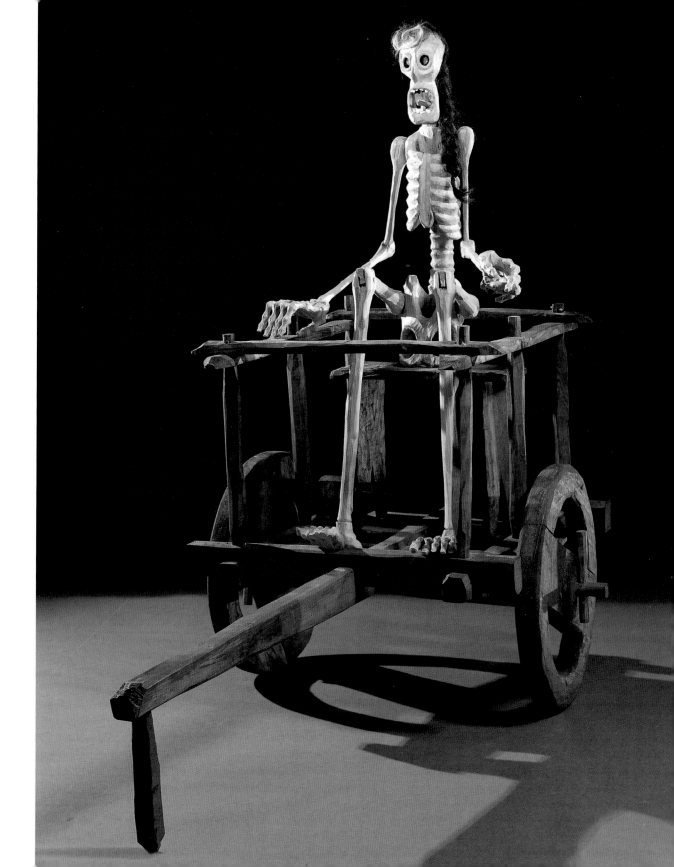

RUBEN TREJO

born 1937

Codex for the 21st Century

1997, nails
152.4 x 609.6 cm
Smithsonian
American Art Museum
Museum purchase
through the Julia D.
Strong Endowment
and the Acquisitions
Gift Fund

Against a stark background, one hundred pairs of nails twist around one another, suggesting images of chromosomes, dancers—even, as Trejo points out, the *Kama Sutra*. The nails, which were specifically bent and rusted by the artist, can be reconfigured. The resulting images resemble abstract characters on a futuristic three-dimensional codex.

Ruben Trejo was born in a boxcar in the Burlington Railroad Yard in Saint Paul, Minnesota. His father worked for the railroad and his mother and siblings worked the fields as migrant laborers. Trejo recognized that Chicano artists were experiencing "cultural doldrums," and as a way to "drive some life into our visual culture," he looked to ancient Aztec and Mayan codices for inspiration. At The Mexican Museum in 1992, Trejo was among several artists commissioned to make collective works that symbolically gathered the lost picture books of the Americas, burned by colonial administrations during the Spanish conquest. This *Codex for the 21st Century* represents another step in that direction, although Trejo communicates in a language that the viewer can only attempt to understand. This deceptively simple work allows the viewer to assume the role of an archaeologist discovering a new, not-yet-deciphered language while engaging in a dialogue about art and culture. As a Náhuatl poet wrote many years ago: "I sing the pictures of the book and see them spread out; I am an elegant bird for I make the codices speak within the house of pictures."

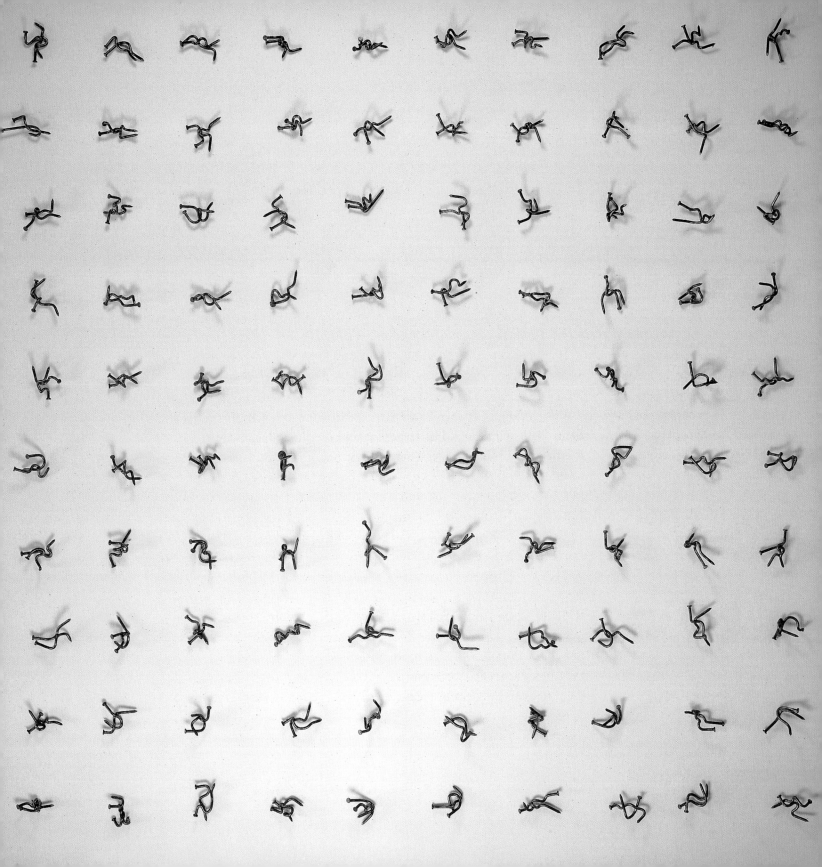

JESSE TREVIÑO

born Mexico 1946

Mis Hermanos (My Brothers)

1976, acrylic
Smithsonian
American Art Museum
Gift of Lionel Sosa,
Ernest Bromley,
Adolfo Aguilar of
Sosa, Bromley, Aguilar
and Associates

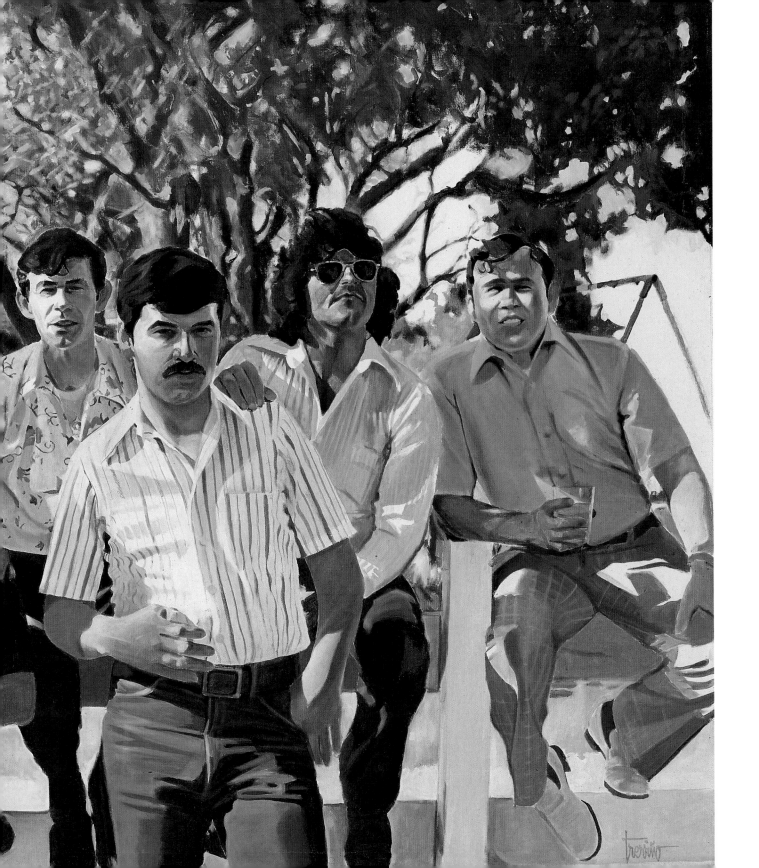

IRVIN L. TRUJILLO

born 1954

The Hook and the Spider

1995
naturally dyed wool
235 x 137.2 x .6 cm
Smithsonian
American Art Museum
Gift of Mr. and Mrs.
Andrew Anderson III

Irvin L. Trujillo, a seventh-generation New Mexican weaver, learned traditional skills as a ten-year-old boy working alongside his father, one of Chimayo's master weavers. Although Irvin earned a degree in engineering in 1984, he soon gave up that profession to continue his family's art form. Trujillo has studied several styles, techniques, and methods. "I try," he has remarked, "to capture the spirit of the old pieces while also expressing my own experience in the contemporary world."

The design of this dazzling textile has several influences, including Saltillo weaving elements, African rhythm in the border, and Rio Grande Vallero eight-point star designs at the ends. The center includes yellow and blue ikat spider designs that were dyed with chamiso, a plant from northern New Mexico, then over-dyed with indigo from central Mexico. To produce the greens, Trujillo combined indigo and chamiso. The different orange shades were dyed with madder root from India and a catechu extract (sap from an acacia bush). As the work progressed, Trujillo noticed all the hook designs, a realization that led to the title *The Hook and the Spider.*

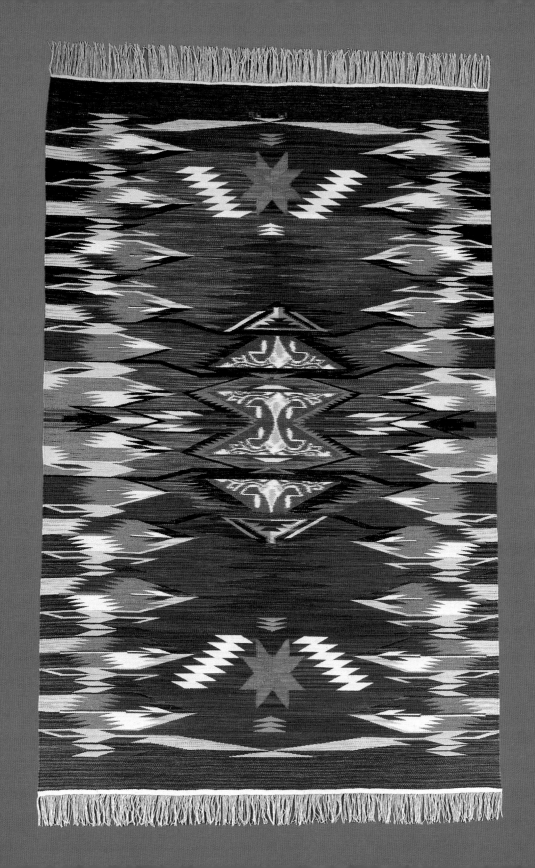

**CONSUELO JIMÉNEZ
UNDERWOOD**

born 1949

Virgen de los Caminos (Virgin of the Roads)

1994, embroidered
and quilted cotton
and silk with graphite
147.3 x 91.4 cm
Smithsonian
American Art Museum

The *Virgen de los Caminos* (Virgin of the Roads) represents a guardian spirit of the poor who make the dangerous crossing between Mexico and the United States. The barbed wire symbolizes geopolitical borders that separate insiders from outsiders, inflicting pain and suffering on both sides. The word "caution" and an image of a fleeing family are taken from road signs in Southern California. Quilted in white thread on white cotton fabric, the elements become almost unnoticeable to the viewer, suggesting that those who enter the country from Mexico are invisible to other members of U.S. society.

Fiber artist and weaver Consuelo Jiménez Underwood is the daughter of migrant agricultural workers, a Chicana mother and a father of Huichol Indian descent. She has degrees in religious studies and art, and today is a tenured professor at San Jose State University in California. In her richly textured creations, she weaves common threads of history and cultural resistance and affirmation.

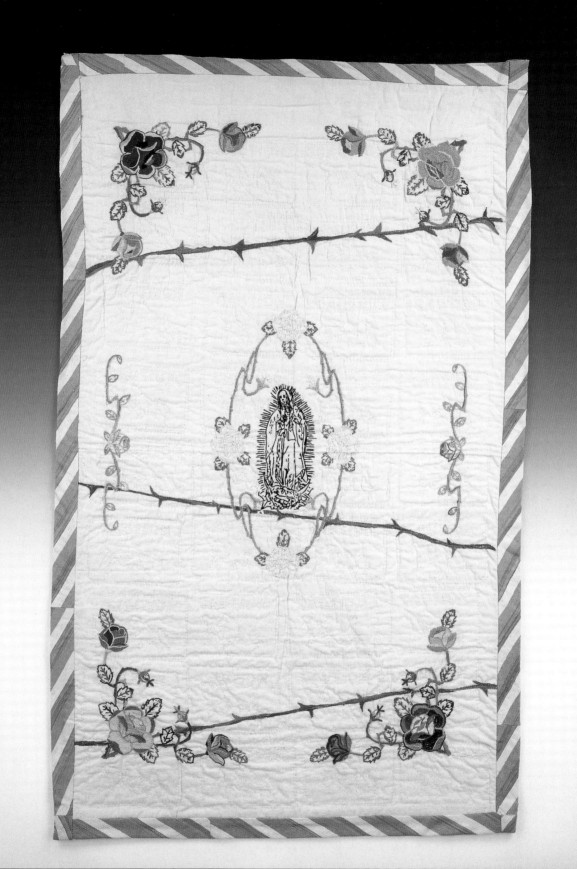

Christ Crucified

about 1820
painted wood with hair
133 x 93.3 x 17.5 cm
Smithsonian
American Art Museum
Museum purchase
through the Smithsonian
Institution Collections
Acquisition Program

This visceral carving of the crucified Christ was produced in the early nineteenth century by an unidentified *santero.* A master at invoking piety through religious sculptures, with deft hands and a clear spiritual vision, he makes vivid Christ's suffering for the sins of the world.

In this wooden sculpture, human hair falls limply over the Savior's scraggy shoulders, emphasizing the figure's lifelike presence. The gaunt, skeletal Christ grimaces not only in physical pain from asphyxia, but also in spiritual pain for humanity. His emaciated body and sunken chest combine to produce a powerful image. The ribs are formed by an abstract, chevron-like design that hovers over a protruding navel. Although blood oozes from wounds, the skin looks desiccated, much like the cross upon which He hangs. Christ's attenuated limbs are countered by a strong, straight torso that tapers to thin, bony legs and nailed feet.

This significant work, remarkable for its pathos, is related to a long tradition of New Mexico carvings of saints' images. A similar crucifixion, perhaps carved by the same artist, is still venerated in a chapel in Cubero, New Mexico.

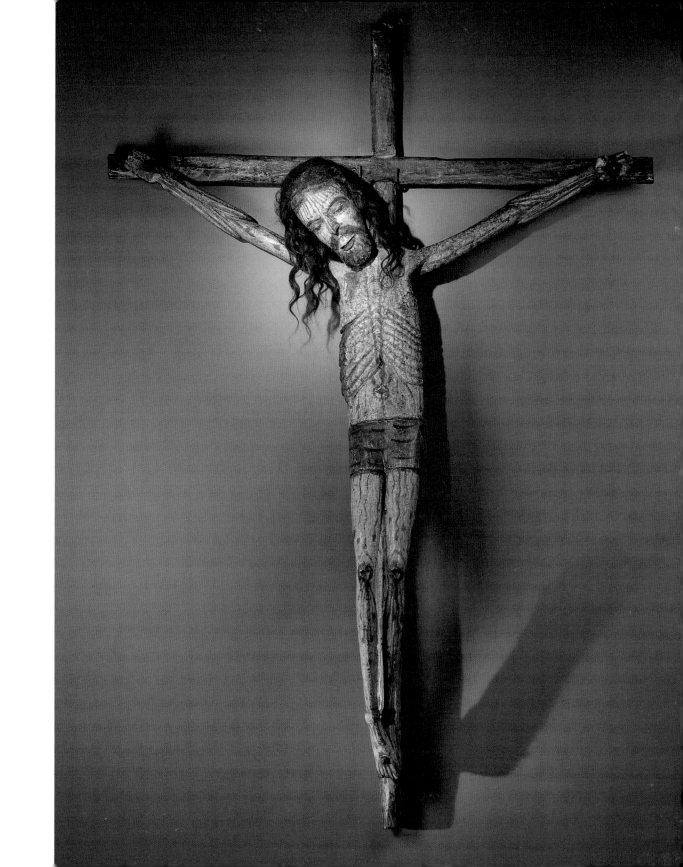

Nuestra Señora de los Dolores
(Our Lady of Sorrows)

about 1675–1725

painted wood

37.8 x 18.4 x 14 cm

Smithsonian

American Art Museum

Teodoro Vidal Collection

Nuestra Señora de los Dolores (Our Lady of Sorrows) is the oldest artwork in the Smithsonian American Art Museum. This striking *santo* is based on a Gospel verse in which Mary was told discomforting words at the presentation of her child in the Temple: "And thy own soul a sword shall pierce, that out of many hearts thought may be revealed" (Luke 2:34–35). These words foretold her future anguish over the painful crucifixion of her son, Jesus Christ.

Carved in a highly dramatic style, this early Puerto Rican figure is reminiscent of seventeenth-century Spanish baroque sculpture found in the island's Catholic churches. The dynamic tension and energy of the Madonna's dark billowy robe symbolize the grief of a tormented mother who has lost her beloved son. Deep pleats lead the viewer's eyes to her clenched hands. With her head mantled, her sorrowful eyes lead ours in the same upward gaze.

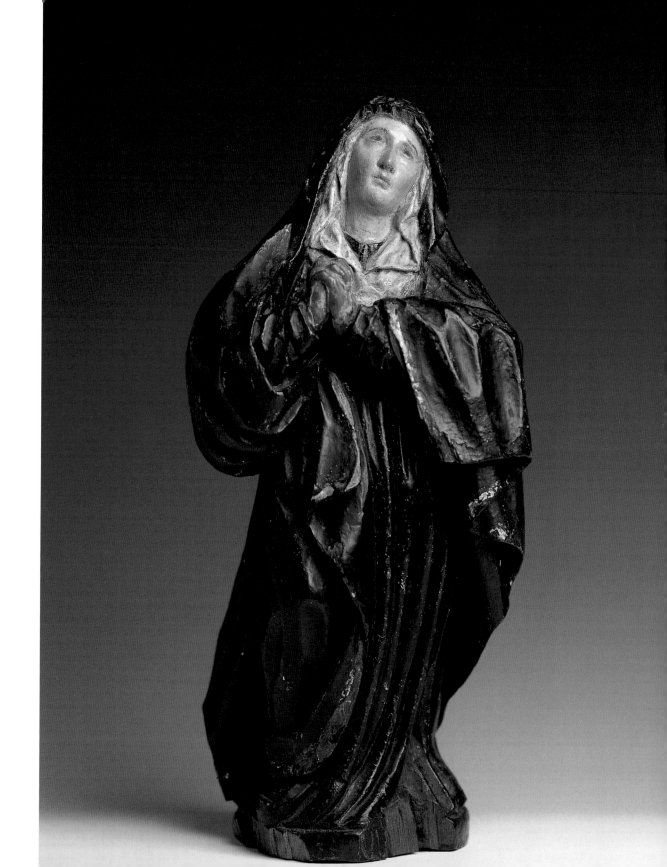

JOHN VALADEZ

born 1951

Two Vendors

1989, pastel
208.9 x 128.3 cm
Smithsonian
American Art Museum
Museum purchase
through the Smithsonian
Institution Collections
Acquisition Program
and the Luisita L. and
Franz H. Denghausen
Endowment

On a hot summer day in downtown Los Angeles, John Valadez was looking for interesting subjects to photograph along Broadway Street. He became transfixed as he watched two men pass one another, each giving the other a look that forcefully proclaimed their right alone to be shirtless. Holding his bright yellow shirt and wearing a chain with a cross and a newspaper hat suggestive of a miter, the young man on the left has a quizzical expression. The other man, also shirtless, adds to the sense of competition. Above them a number of female heads float amidst dolls and the Virgin. Valadez, a superb draftsman and brilliant colorist, captured this moment in stunning pastel. The dreamlike scene evokes sources such as Spanish language television and *foto-novellas.* The pastel's overall color scheme mimics the broad multihued bands of the serape.

As a youth in Los Angeles, Valadez played between the freeway and the river. While attending East Los Angeles Junior College he joined a theater group that presented plays in prisons and community centers. In the late 1970s, he, along with Carlos Almaraz, Frank Romero, and Richard Duarto, founded the Public Arts Center in Highland Park, which provided studio space and access to cooperative mural projects.

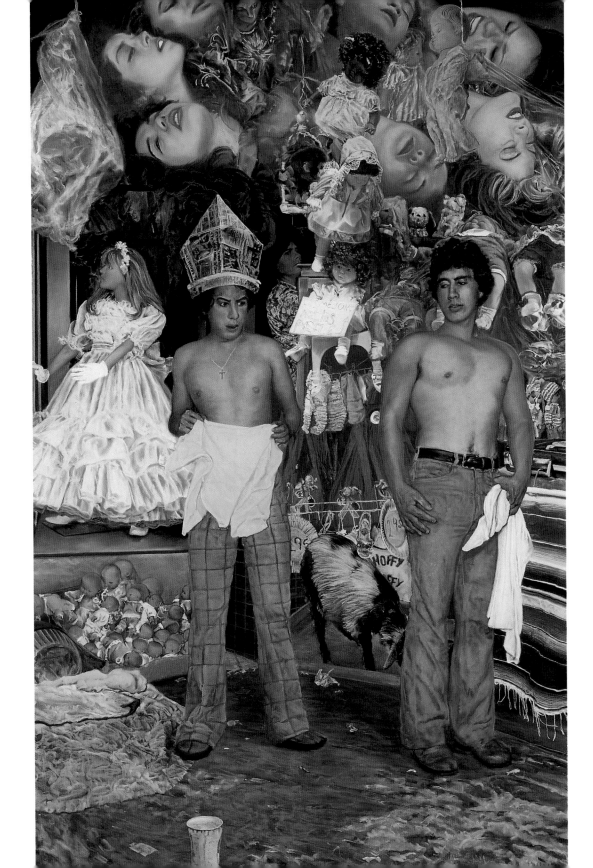

HORACIO VALDEZ

1929–1992

Nuestra Señora la Reina del Cielo (Our Lady, Queen of Heaven)

1991, painted wood
with metal and silver
79.4 x 24.1 x 19.1 cm
Smithsonian
American Art Museum
Gift of Chuck and
Jan Rosenak and
museum purchase
through the
Luisita L. and
Franz H. Denghausen
Endowment

Valdez, a carpenter for twenty-five years, had a nearly fatal job accident in 1974, during which his right hand was crushed. It was then that Valdez began to carve, "just to pass the time." He was fond of saying, *"No hay mal, que por bien no venga"* (Nothing bad ever happens without resulting in some good). A self-taught carver and painter, Valdez—who recalled being initiated as a member of the *Penitente* brotherhood the day following his first carving—was a devoutly religious man. Among the prolific artist's many carvings were more than 250 crucifixes.

This Virgin Mary wears a deep blue bodice with bright red collar. A blend of colors, curves, and contours, the figure is exquisitely carved and painted, in acrylics rather than natural pigments. In a more traditional carving the Virgin Mary would be holding the Christ Child and a scepter. In Valdez's version, however, she wears a silver crown with bright red accents and holds a palm frond in her left hand. The large stylized dove is a symbol of peace and the Holy Trinity. Her image, based on a passage in the Book of Revelations, *La Reina del Cielo,* or Our Queen of Heaven, offers protection from preternatural dangers.

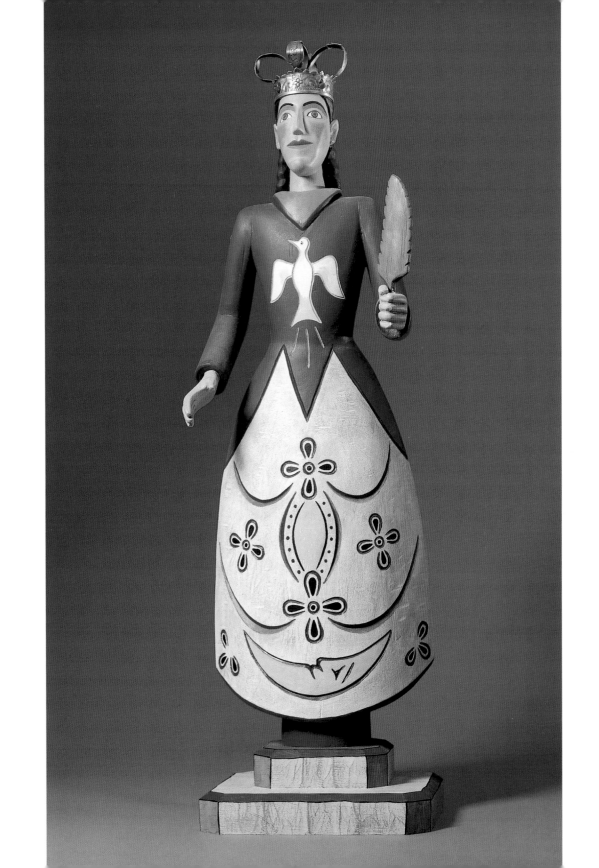

PATSSI VALDEZ

born 1951

The Magic Room

1994, acrylic
243.8 x 303.8 cm
Smithsonian
American Art Museum
Museum purchase
through the
Smithsonian Institution
Collections Acquisition
Program

Vibrant, saturated colors electrify this topsy-turvy, magical room, where heavy theatrical curtains frame a wild and energetic scene. Nothing is stable: carpet patterns swirl like whirlpools, wine glasses topple, chairs tip, rock, and float. Gymnastic rings swing freely side-to-side, as four balls on their own bounce merrily through the room. The green chair on the left climbs the thick curtain while a blue chair dances sensuously with the table—forks hanging on for dear life. Overall, the effect is dizzying, yet, despite the uneasy perspective, a balance exists between fantasy and reality. As Patssi Valdez has remarked, "My goal is to keep the paintings alive, to give them a sense of movement. I want to evoke a feeling that people just left the room."

As an artist growing up in East Los Angeles, Valdez was the only Chicana in the conceptual performance group Asco (Spanish for nausea). Valdez is a multitalented artist in several media, including performance and conceptual art, installations, murals, fashion design, collage, photography, easel painting, and set design. Her painted domestic interiors often function as self-portraits—intimate glimpses into internal thoughts and feelings.

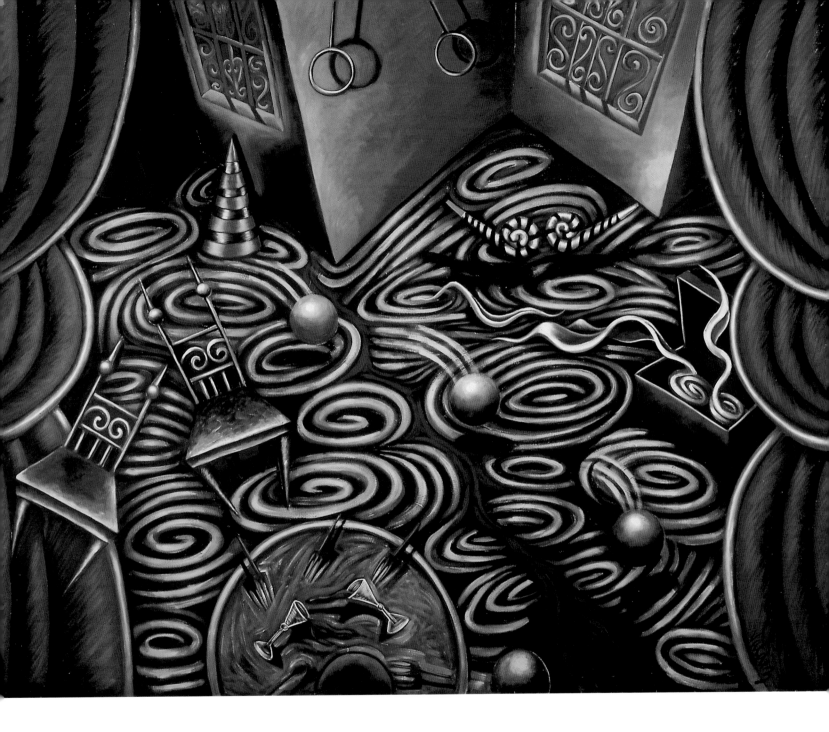

KATHY VARGAS

born 1950

Missing #3

1992, hand-colored
silver prints
each 61 x 50.8 cm
Smithsonian
American Art Museum
Museum purchase
made possible by the
Horace W. Goldsmith
Foundation

Kathy Vargas draws upon pre-Columbian myths, Mexican Catholicism, Latin American magical realism, and vivid childhood experiences in San Antonio to express the dreams, memories, and nostalgia depicted in her manipulated photographs.

Missing #3 consists of six hand-colored gelatin silver prints that she created through multiple-exposure photography. Together they create a haunting, poetic memento mori (reminder of the cycle of life, death, and resurrection). In this X-ray-like image, a dark and lifeless bird is tucked into a band of clothing, feathers are strewn about, and broken twigs form an abstract pattern. The inspiration for the artwork came from a dream in which Vargas was lying in a coffin. As mourners paid their final respects, she was transformed into a bird. This is symbolized in the central panels, in which the bird and skeleton merge. To the right, she said, "is an image . . . waiting to wing out, but willing to walk for now." Multiple hands appear, the palm in the upper left print mirrored by the skeletal one in the lower center. This hand-colored image bears the artist's imprint throughout. An inscription on the back reads: "At some point the two dreams merged into a recognizable self-portrait."

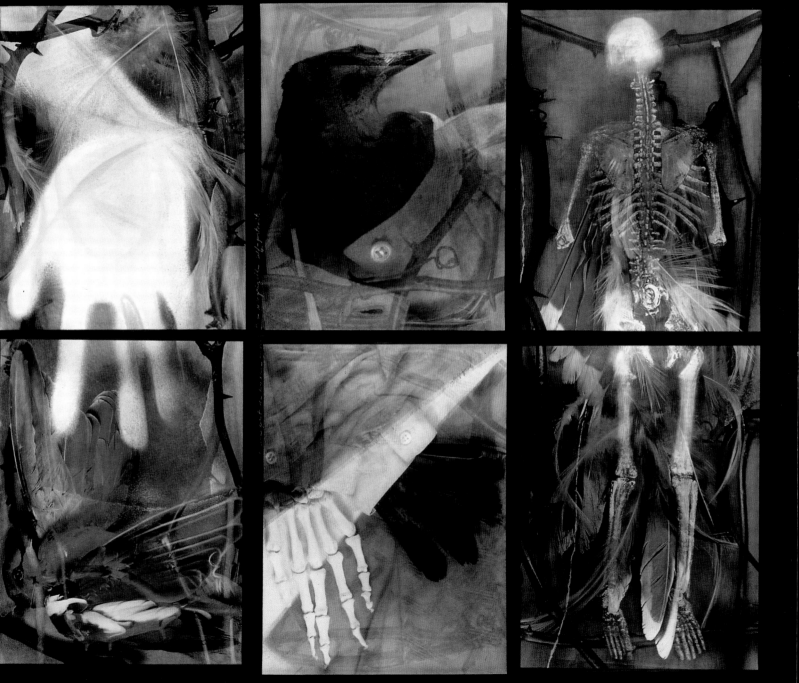

Index of Titles

The Smithsonian American Art Museum is dedicated to telling the story of America through the visual arts. The museum, whose publications program includes the scholarly journal *American Art*, also has extensive research resources: the databases of the Inventories of American Painting and Sculpture, several image archives, and fellowships for scholars. The Renwick Gallery, the nation's premier museum of modern American decorative arts and craft, is part of the Smithsonian American Art Museum. For more information or catalogue of publications, write: Office of Print and Electronic Publications, Smithsonian American Art Museum, Washington, D.C. 20560-0230.

The museum also maintains a World Wide Web site at **AmericanArt.si.edu.**